Bibliothek der Mediengestaltung

Konzeption, Gestaltung, Technik und Produktion von Digital- und Printmedien sind die zentralen Themen der Bibliothek der Mediengestaltung, einer Weiterentwicklung des Standardwerks Kompendium der Mediengestaltung, das in seiner 6. Auflage auf mehr als 2.700 Seiten angewachsen ist. Um den Stoff, der die Rahmenpläne und Studienordnungen sowie die Prüfungsanforderungen der Ausbildungs- und Studiengänge berücksichtigt, in handlichem Format vorzulegen, haben die Autoren die Themen der Mediengestaltung in Anlehnung an das Kompendium der Mediengestaltung neu aufgeteilt und thematisch gezielt aufbereitet. Die kompakten Bände der Reihe ermöglichen damit den schnellen Zugriff auf die Teilgebiete der Mediengestaltung.

Weitere Bände in der Reihe: http://www.springer.com/series/15546

Peter Bühler
Patrick Schlaich
Dominik Sinner

Digitale Farbe

Farbgestaltung – Colormanagement – Farbverarbeitung

Peter Bühler
Affalterbach, Deutschland

Dominik Sinner
Konstanz-Dettingen, Deutschland

Patrick Schlaich
Kippenheim, Deutschland

ISSN 2520-1050 ISSN 2520-1069 (electronic)
Bibliothek der Mediengestaltung
ISBN 978-3-662-54606-2 ISBN 978-3-662-54607-9 (eBook)
https://doi.org/10.1007/978-3-662-54607-9

Die Deutsche Nationalbibliothek verzeichnet diese Publikation in der Deutschen Nationalbibliografie; detaillierte
bibliografische Daten sind im Internet über http://dnb.d-nb.de abrufbar.

Springer Vieweg
© Springer-Verlag GmbH Deutschland 2018

Gedruckt auf säurefreiem und chlorfrei gebleichtem Papier

Springer Vieweg ist Teil von Springer Nature
Die eingetragene Gesellschaft ist Springer-Verlag GmbH Deutschland
Die Anschrift der Gesellschaft ist: Heidelberger Platz 3, 14197 Berlin, Germany

The Next Level – aus dem Kompendium der Mediengestaltung wird die Bibliothek der Mediengestaltung.

Im Jahr 2000 ist das „Kompendium der Mediengestaltung" in der ersten Auflage erschienen. Im Laufe der Jahre stieg die Seitenzahl von anfänglich 900 auf 2700 Seiten an, so dass aus dem zunächst einbändigen Werk in der 6. Auflage vier Bände wurden. Diese Aufteilung wurde von Ihnen, liebe Leserinnen und Leser, sehr begrüßt, denn schmale Bände bieten eine Reihe von Vorteilen. Sie sind erstens leicht und kompakt und können damit viel besser in der Schule oder Hochschule eingesetzt werden. Zweitens wird durch die Aufteilung auf mehrere Bände die Aktualisierung eines Themas wesentlich einfacher, weil nicht immer das Gesamtwerk überarbeitet werden muss. Auf Veränderungen in der Medienbranche können wir somit schneller und flexibler reagieren. Und drittens lassen sich die schmalen Bände günstiger produzieren, so dass alle, die das Gesamtwerk nicht benötigen, auch einzelne Themenbände erwerben können. Deshalb haben wir das Kompendium modularisiert und in eine Bibliothek der Mediengestaltung mit 26 Bänden aufgeteilt. So entstehen schlanke Bände, die direkt im Unterricht eingesetzt oder zum Selbststudium genutzt werden können.

Bei der Auswahl und Aufteilung der Themen haben wir uns – wie beim Kompendium auch – an den Rahmenplänen, Studienordnungen und Prüfungsanforderungen der Ausbildungs- und Studiengänge der Mediengestaltung orientiert. Eine Übersicht über die 26 Bände der Bibliothek der Mediengestaltung finden Sie auf der rechten Seite. Wie Sie sehen, ist jedem Band eine Leitfarbe zugeordnet, so dass Sie bereits am Umschlag erkennen, welchen Band Sie in der Hand halten. Die Bibliothek der Mediengestaltung richtet sich an alle, die eine Ausbildung oder ein Studium im Bereich der Digital- und Printmedien absolvieren oder die bereits in dieser Branche tätig sind und sich fortbilden möchten. Weiterhin richtet sich die Bibliothek der Mediengestaltung auch an alle, die sich in ihrer Freizeit mit der professionellen Gestaltung und Produktion digitaler oder gedruckter Medien beschäftigen. Zur Vertiefung oder Prüfungsvorbereitung enthält jeder Band zahlreiche Übungsaufgaben mit ausführlichen Lösungen. Zur gezielten Suche finden Sie im Anhang ein Stichwortverzeichnis.

Ein herzliches Dankeschön geht an Herrn Engesser und sein Team des Verlags Springer Vieweg für die Unterstützung und Begleitung dieses großen Projekts. Wir bedanken uns bei unserem Kollegen Joachim Böhringer, der nun im wohlverdienten Ruhestand ist, für die vielen Jahre der tollen Zusammenarbeit. Ein großes Dankeschön gebührt aber auch Ihnen, unseren Leserinnen und Lesern, die uns in den vergangenen fünfzehn Jahren immer wieder auf Fehler hingewiesen und Tipps zur weiteren Verbesserung des Kompendiums gegeben haben.

Wir sind uns sicher, dass die Bibliothek der Mediengestaltung eine zeitgemäße Fortsetzung des Kompendiums darstellt. Ihnen, unseren Leserinnen und Lesern, wünschen wir ein gutes Gelingen Ihrer Ausbildung, Ihrer Weiterbildung oder Ihres Studiums der Mediengestaltung und nicht zuletzt viel Spaß bei der Lektüre.

Heidelberg, im Frühjahr 2018
Peter Bühler
Patrick Schlaich
Dominik Sinner

Bibliothek der Mediengestaltung

Titel und
Erscheinungsjahr

3 Color Management 38

4 Anhang 96

Sind Sie farb-tüchtig? (42)

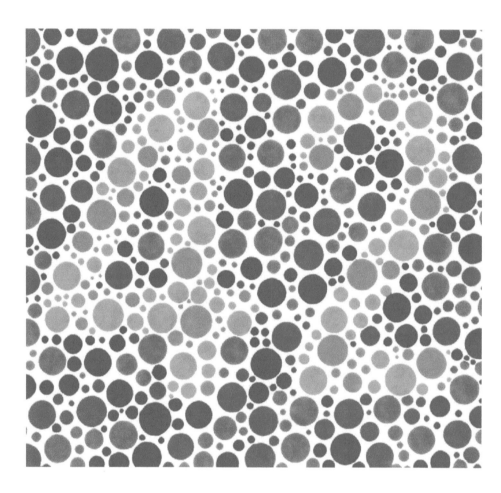

„»Wir sind diejenigen«, sagte Phougg, »denen er die Antwort geben wird auf die große Frage nach dem Leben ...!« »... dem Universum ...«, sagte Luun-quoal.
»... und allem ...!«
...
»Sie wird euch bestimmt nicht gefallen «, bemerkte Deep Thought.
»Sag sie uns trotzdem!«
»Na schön«, sagte Deep Thought.
»Die Antwort auf die Große Frage ...«
»Ja ...!«
»... nach dem Leben, dem Universum und allem ...«, sagte Deep Thought.

»Ja ...!«
»...lautet ...«, sagte Deep Thought und machte eine Pause.
»Ja ...!«
»...lautet ...«
»Ja ...!!!...???«
»Zweiundvierzig«, sagte Deep Thought mit unsagbarer Erhabenheit und Ruhe.“

Douglas Adams: Per Anhalter durch die Galaxis

© Springer-Verlag GmbH Deutschland 2018
P. Bühler, P. Schlaich, D. Sinner, *Digitale Farbe*, Bibliothek der Mediengestaltung,
https://doi.org/10.1007/978-3-662-54607-9_1

1.1 Farbe ist Licht

Ohne Licht herrscht die Dunkelheit, wir sehen nichts. Aber woher kommt das Licht, das wir sehen?

Anders als Comic-Helden mit Röntgenblick senden unsere Augen keine Strahlung aus, sondern sie empfangen sie nur. Licht braucht also eine Quelle, d.h., das Licht muss zum Auge kommen. Die Lichtquelle strahlt das Licht ab, es trifft auf einen Körper und wird von diesem zurückgestrahlt oder es trifft direkt von einer Lichtquelle auf unser Auge.

Sekundärstrahler

nichtselbstleuchtender Körper, z. B. Mond, Druck

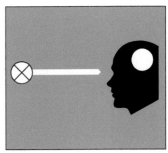

Primärstrahler

selbstleuchtender Körper oder Lichtquelle, z. B. Sonne, Monitor

1.1.1 Lichtspektrum

Isaac Newton bewies in verschiedenen Experimenten die Zusammensetzung von weißem Licht aus farbigem Licht unterschiedlicher Wellenlängen. Beim Durchgang durch ein Prisma werden die einzelnen Wellenlängen unterschiedlich stark gebrochen. Dadurch erscheint auf dem Projektionsschirm das Spektrum von Rot über Gelb, Grün und Cyan bis Blau.

Das für den Menschen sichtbare Licht umfasst die Wellenlängen eines schmalen Spektralbereichs von 380 nm bis 760 nm.

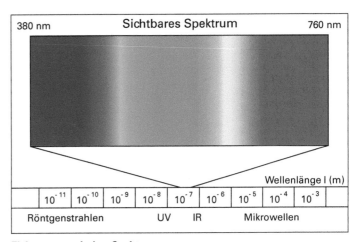

Elektromagnetisches Spektrum

1.1.2 Lichtwellen

Die optische Wirkung des Lichts wird vor allem durch das Verhalten des Lichts als Welle bestimmt. In der Fotografie und der Medienproduktion sind für uns zwei Eigenschaften des Lichts von besonderer Bedeutung:
- Farbigkeit und
- Helligkeit.

Die von uns wahrgenommene Farbe des Lichts wird durch die Wellenlänge bestimmt. Die Helligkeit des Lichts ist von der Amplitude der Lichtwelle abhängig.

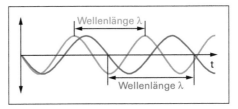

Wellenlänge
bestimmt die Farbigkeit des Lichts

Amplitude
bestimmt die Helligkeit des Lichts

1.2 Mit den Augen sehen

Was passiert in unseren Augen, wenn wir etwas sehen? Die erste Antwort ist immer die, dass unser Auge wie eine Kamera funktioniert. Es ist ebenso ein optisches System, das statt eines Sensors eben die Netzhaut als Empfänger hat.

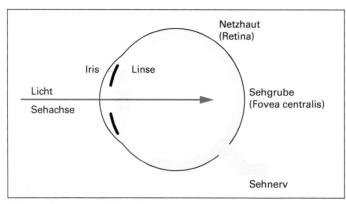

Schema des menschlichen Auges

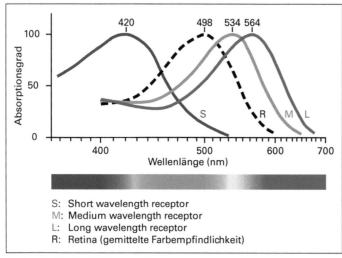

S: Short wavelength receptor
M: Medium wavelength receptor
L: Long wavelength receptor
R: Retina (gemittelte Farbempfindlichkeit)

Spektrale Empfindlichkeit der Zapfen

Die auf der Netzhaut befindlichen Rezeptoren wandeln die visuellen Informationen in nervöse Signale um. Diese Signale werden dann zur weiteren Ver-

arbeitung an das Gehirn geleitet. Erst dort entsteht das Bild, das wir sehen, oder besser, das wir wahrnehmen.

1.2.1 Stäbchen und Zapfen

Auf der Netzhaut, Retina, des menschlichen Auges befinden sich lichtempfindliche Zellen. Sie werden als Pigmentoder Photorezeptoren bezeichnet. Es gibt zwei Arten von Rezeptoren, die nach Form und Funktion unterschieden werden, Stäbchen und Zapfen. Die Netzhaut hat etwa 120 Millionen Stäbchen und nur ca. 7 Millionen Zapfen. Die überwiegende Mehrzahl der Zapfen konzentriert sich in der Fovea, dem Sehzentrum des Auges.

Die Stäbchen haben keine spektrale Empfindlichkeit, sie können ausschließlich Helligkeiten unterscheiden. Die Zapfen sind farbempfindlich, etwa ein Drittel der Zapfen jeweils für rotes, grünes und blaues Licht. Sie sehen also nur drei Farben: Rot, Grün und Blau. Alle anderen Farben sind das Ergebnis der Signalverarbeitung und Bewertung im Sehzentrum des Gehirns.

Bei ausreichender Helligkeit sehen wir vor allem mit den Zapfen, bei schwacher Beleuchtung, z. B. in der Dämmerung, sehen wir vor allem mit den Stäbchen. Sie kennen sicherlich den Ausspruch: „Nachts sind alle Katzen grau." Das Farbensehen ist also stark von der Beleuchtung bzw. von der ins Auge fallenden Lichtmenge abhängig.

1.2.2 Farbfehlsichtigkeit

Menschen mit Farbfehlsichtigkeit haben eine abweichende spektrale Empfindlichkeit der Zapfen. Die häufigste Art der Farbfehlsichtigkeit ist die Rot/Grün-Schwäche oder Rot/Grün-Blindheit. Von

ihr sind etwa 8 % aller Männer und nur etwa 0,8 % der Frauen betroffen.

Die beiden rechtsstehenden Abbildungen zeigen als Simulation, wie Menschen mit Farbfehlsichtigkeit im Rot/Grün-Bereich des Spektrums die Farbtafel auf Seite 2 sehen.

In Photoshop können Sie die Simulation unter Menü *Ansicht > Proof einrichten > Farbenblindheit* als Softproof anwählen. Eine sehr sinnvolle Funktion, um die Farbwirkung z. B. im Screendesign hinsichtlich der Barrierefreiheit zu testen.

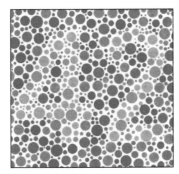
Protanopie – Rotschwäche

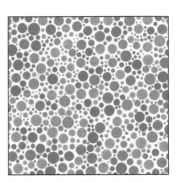
Deuteranopie – Grünschwäche

1.2.3 Farbmaßzahlen und Normalbeobachter

Der Mensch ist das Maß aller Dinge. Aber jeder Mensch ist anders. Genauso wie es große und kleine, dunkelhaarige und blonde Menschen gibt, genauso unterscheidet sich unser Sehsinn und unsere Farbwahrnehmung. Zur standardisierten und konsistenten Produktion farbiger Medien ist es deshalb notwendig, allgemein gültige auf dem menschlichen Farbensehen basierende Kenngrößen zur Farbbewertung zu haben.

Normalbeobachter
Mit drei in ihrer Intensität regelbaren Lichtquellen der Primärfarben Rot, Grün und Blau kann jede Spektralfarbe nachgestellt werden. Auf ein Vergleichsfeld wird, über eine verschiebbare Blende gesteuert, jeweils das monochromatische Licht einer Wellenlänge aus dem Spektrum gestrahlt. Der Beobachter regelt nun die Farbanteile von Rot, Grün und Blau so, dass die beiden Vergleichsfelder farblich visuell gleich erscheinen.

Als Ergebnis erhält man die Empfindlichkeit des menschlichen Auges für die einzelnen Spektralfarben. Dieser

Versuch wurde mit einer ganzen Reihe von Beobachtern durchgeführt. Das Mittel der Versuchsergebnisse wurde dem sogenannten Normalbeobachter zugeschrieben. Da die Ergebnisse 1931 von der CIE, Commission Internationale de l'Eclairage, Internationale Beleuchtungskommission, vorgestellt wurden, spricht man auch von dem CIE-1931-Normalbeobachter. Die Versuchsreihen wurden jeweils mit einem Beobachtungswinkel von 2° und von 10° durchgeführt.

Aus dem Gleichheitsurteil des Normalbeobachters werden die Normspektralwertfunktionen für Rot, Grün und

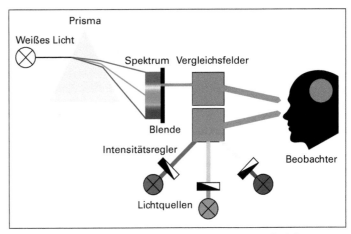

Normalbeobachter – Bestimmung der Normspektralwertfunktionen

5

Blau als Basiswerte für die spektralfotometrische Messung abgeleitet. Die Normspektralwertfunktionen entsprechen der gemittelten spektralen Empfindlichkeit des menschlichen Sehsinns.

Normspektralwertkurven

für den 2°-Normalbeobachter nach DIN 5033 Teil 2

Sekundärstrahler

Primärstrahler

Sekundärstrahler – Nichtselbstleuchter

Die Farbreizfunktion eines Sekundärstrahlers ist das Produkt aus der Strahlungsfunktion S(λ) und der spektralen Remissionsfunktion R(λ) oder β(λ) der Oberfläche eines beleuchteten Körpers bzw. der Transmissionsfunktion T(λ) oder τ(λ) einer transparenten Probe.

Die Farbe eines Sekundärstrahlers heißt Körperfarbe. Praxisbeispiele sind Drucksachen und Verpackungen.

Primärstrahler – Selbstleuchter

Die Farbreizfunktion ist bei einem Primärstrahler gleich der Strahlungsfunktion S(λ) des Strahlers.

Die Farbe eines Primärstrahlers nennt man Lichtfarbe. Praxisbeispiele sind Leuchten, Monitore und Displays.

Farbreiz φ(λ)

Als Farbreiz wird die Strahlung bezeichnet, die durch Reizung der Zapfen eine Farbempfindung hervorruft. Die spektrale Zusammensetzung des Farbreizes wird durch die Farbreizfunktion beschrieben.

Farbreiz	π

$$\varphi = S(\lambda) \cdot \beta(\lambda)$$

Farbvalenz

Die Farbvalenz ist die Bewertung der visuellen Wirkung des Farbreizes durch die drei Empfindlichkeitsfunktionen, d.h. die rot-, grün- und blauempfindlichen Zapfen des menschlichen Auges. Der Farbreiz ist ein physikalischer Vorgang. Er lässt sich damit auch messen. Wir werden im Kapitel *Farbsysteme* auf Seite 13 wieder darauf zurückkommen.

Unser Auge ist kein physikalischer, sondern ein physiologischer Strahlungsempfänger. Zwar rezipieren wir die eintreffende Strahlung durch die rot-, grün- und blauempfindlichen Zapfen, wir können aber das Verhältnis der drei Teilfarbreize für Rot, Grün und Blau für eine bestimmte Farbe nicht auflösen. Wir nehmen deshalb die Farbvalenz als Farbeindruck wahr.

1.3 Mit allen Sinnen wahrnehmen

Von den fünf Sinnesorganen des Menschen, Auge, Haut, Nase, Ohr und Zunge, ist das Auge das wichtigste. Etwa 70 Prozent aller Umweltreize werden über den Sehsinn wahrgenommen. Was wir sehen und was wir wahrnehmen ist nicht immer das Gleiche. Außer durch die Meldungen der anderen Sinnesorgane wird unsere Wahrnehmung auch durch Erfahrungen und die jeweilige Stimmung beeinflusst. Der Seh- oder Gesichtssinn des Menschen steht in enger Beziehung zu den anderen vier Sinnen, dem Tastsinn, dem Geruchssinn, dem Geschmackssinn und dem Hörsinn. Die Wahrnehmung eines Sinnesorgans ist immer ein Zusammenwirken aller Sinnesreize.

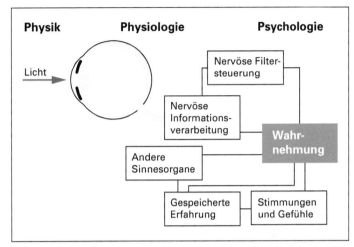

Visuelle Wahrnehmung
Schematische Darstellung der verschiedenen Einflussfaktoren

1.3.1 Visuelle Wahrnehmung

Die visuelle Wahrnehmung wird nicht nur durch das auf der Netzhaut des Auges abgebildete Reizmuster bestimmt, vielmehr ist die Wahrnehmung das Ergebnis der Interpretation der jeweils verfügbaren Daten. Wahrnehmung ist also nicht wirklich wahr. Was Sie wie wahrnehmen, ist nicht nur das Ergebnis der Physiologie des Sehvorgangs. Ihre Wahrnehmung wird ebenfalls stark durch die Psychologie und Ihr subjektives Empfinden bestimmt. Das Auge sieht, aber das Gehirn nimmt wahr.

1.3.2 Farbkontraste

Farben werden immer in ihrem Umfeld wahrgenommen. Farben stehen nie alleine, außer in riesigen Farbflächen, sondern sie sind immer in Wechselwirkung mit ihrer Nachbarfarbe. Diese Beziehung der Farben nennt man Farbkontrast. Auch wenn sich die Farbfläche „nur" auf einer weißen Fläche, z. B. weißem Papier, befindet, hat sie eine

besondere Wirkung, die sich von der auf einer grauen oder farbigen Fläche unterscheidet. Ein Grund für dieses Phänomen ist, dass die für das Farbsehen zuständigen Zapfen auf sehr komplexe Weise untereinander „verdrahtet" sind. Wenn z. B. Zapfen mit rotem Licht erregt werden, dann vermindert sich die Empfindlichkeit der nebenstehenden Zapfen für dieses Licht. Der Effekt heißt laterale Hemmung. Diese visuelle Abhängigkeit von Farben beeinflusst die Beurteilung und Bewertung des Betrachters.

In der Mediengestaltung sind eine ganze Reihe Farbkontraste von Bedeutung.
- Simultankontrast
- Bunt-Unbunt-Kontrast
- Warm-Kalt-Kontrast
- Hell-Dunkel-Kontrast
- Qualitätskontrast
- Quantitätskontrast
- Komplementärkontrast

Als Beispiel für die visuelle Wirkung der zeigen wir den Simultankontrast.

Komplement
lat. Ergänzung

Simultankontrast

Benachbarte Farben beeinflussen ihre Wirkung wechselseitig. Die Farben wirken anders als bei der isolierten Betrachtung nur einer Farbe. Sie können diesen Effekt leicht selbst nachvollziehen, wenn Sie die Kontrastbeispiele zuerst im Ganzen ansehen und dann die jeweilige Umgebungsfarbe mit einer Maske abdecken und die Farbflächen für sich betrachten. Man nennt dieses Phänomen Simultan- oder Umfeldkontrast. Dabei wirkt die größere Fläche immer auf die kleinere Fläche.

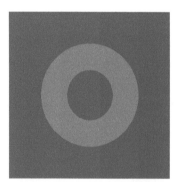
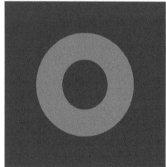

Making of ...

Beurteilen und bewerten Sie die Farbmuster auf dieser Seite visuell. Beschreiben Sie Ihren Farbeindruck und die Farbwirkung. Geben Sie den Farben einen Namen.

1 Erstellen Sie sich zwei Beurteilungsmasken. Schneiden Sie dazu eine Öffnung mit ca. 5 mm Kantenlänge bzw. Durchmesser in die Mitte eines weißen und eines schwarzen Kartons.

2 Legen Sie die schwarze Beurteilungsmaske auf die Farbfläche.

3 Beschreiben Sie das Farbmuster hinsichtlich
 - Farbton
 - Buntheit
 - Farbwirkung

4 Führen Sie die visuelle Beurteilung der Farbe mit der weißen Beurteilungsmaske durch.

5 Vergleichen Sie die Ergebnisse der beiden Abmusterungen.

6 Geben Sie der abgemusterten Farbe einen Farbnamen.

7 Führen Sie die Abmusterung mit anderen Farbmustern durch. Vergleichen Sie Ihre Ergebnisse mit den Ergebnissen anderer Personen.

1.4 Aufgaben

1 Farbensehen erläutern

Beschreiben Sie das Prinzip des Farbensehens.

2 Farbvalenz definieren

Definieren Sie den Begriff Farbvalenz.

3 Farbkontraste kennen

Nennen Sie vier Farbkontraste.

1.

2.

3.

4.

4 Farbkontraste in ihrer Wirkung beschreiben

Welcher Farbkontrast beschreibt die Wirkung einer Farbe in ihrem Umfeld?

5 Kenngrößen einer Welle definieren

Definieren Sie die Kenngrößen einer Welle:
a. Wellenlänge
b. Amplitude

a.

b.

6 Strahlerarten erläutern

Beschreiben Sie den Strahlungsverlauf bei
a. Primärstrahlern und
b. Sekundärstrahlern?

a.

b.

7 Visuelle Wahrnehmung erläutern

Nennen Sie vier Faktoren, die die visuelle Wahrnehmung beeinflussen.

1.

2.

3.

4.

2.1 Beleuchtung

Die Beleuchtung macht die Farbe.

Die spektrale Strahlungsverteilung der Beleuchtung bildet als Produkt mit dem spektralen Remissionsspektrum der Oberfläche den Farbreiz, der in unser Auge trifft. Wir können die Faktoren des Farbreizes nicht im Einzelnen auflösen, sondern nehmen die Farberregung der Stäbchen und Zapfen auf der Netzhaut

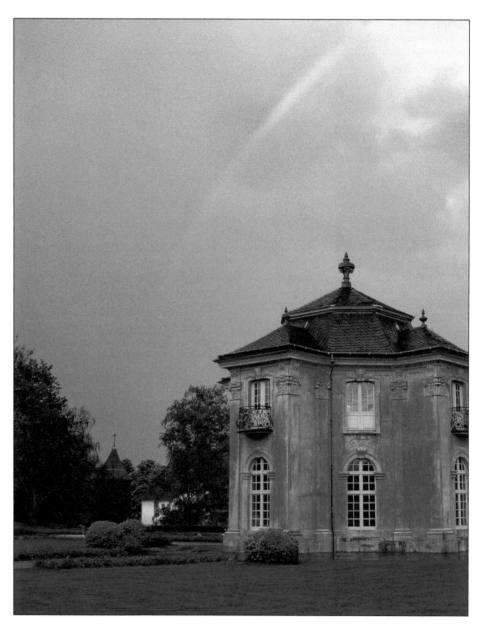

© Springer-Verlag GmbH Deutschland 2018
P. Bühler, P. Schlaich, D. Sinner, *Digitale Farbe*, Bibliothek der Mediengestaltung,
https://doi.org/10.1007/978-3-662-54607-9_2

als Farbvalenz wahr. Für einen kontrollierten konsistenten Farbworkflow in der Print- und Digitalmedienproduktion ist es deshalb notwendig, die spektralen Eigenschaften der Beleuchtungsquellen zu kennen und für die Praxis festzulegen.

2.1.1 Farbtemperatur

Ein wesentliches Kennzeichen für die Farbigkeit einer Lichtquelle ist die spektrale Verteilung der abgestrahlten, d.h. emittierten Strahlung. Sie wird häufig mit dem Begriff Farbtemperatur gekennzeichnet. Die Einheit der Farbtemperatur ist Kelvin K, die SI-Einheit für die Temperatur.

Warmes Licht hat einen höheren Rotanteil, kaltes Licht einen höheren Blauanteil. Im neutral weißen Licht sind alle Wellenlängen gleichgewichtig enthalten. 5000 K entspricht der Oberflächentemperatur der Sonne und damit einem mittleren neutralen Weiß. Eine Lichtquelle mit einer Farbtemperatur von 10000 K emittiert sehr viel blaues Licht. 2500 K entspricht dem rötlichen warmen Licht früher gebräuchlicher Glühlampen.

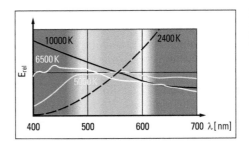

Farbtemperaturen
Relative spektrale Energieverteilung

Lichtquelle	Farbtemperatur
Kerzenlicht	ca. 1900 K
Glühlampe	ca. 2400 K
Mondlicht	ca. 4100 K
Sonnenlicht	5600 K – 6500 K
bedeckter Himmel	6500 K – 7000 K
blauer Himmel	12000 K – 27000 K
Normlicht D50	5000 K
Normlicht D65	6500 K

Farbtemperaturen
Verschiedene Lichtquellen

2.1.2 Normlicht

Der Farbreiz ist das Produkt der spektralen Emission einer Beleuchtungsquelle und der spektralen Remission einer Körperfarbe. Die beiden Faktoren können beim Sehen nicht aufgelöst werden. Wir nehmen die Farbreize der drei Lichtgrundfarben Rot, Grün und

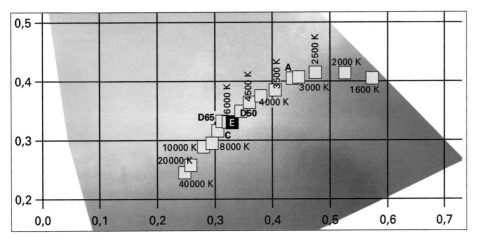

Weißpunkte einzelner Farbtemperaturen

mit den Normlichtarten D50, D65, C und A sowie dem Unbuntpunkt E

11

Blau addiert als Farbvalenz wahr. Bei der visuellen Abmusterung und der messtechnischen Erfassung einer Farbe muss deshalb der Faktor Beleuchtung als Normlicht konstant gehalten werden. Seit den 1970er Jahren ist für die Druckindustrie in der Norm ISO 3664 als Normlicht ein mittleres Tageslicht mit einer Farbtemperatur von 5003 K als D 50 (engl. Daylight) festgelegt. Um den zunehmenden Anteil an optischen Aufhellern in Druckpapieren zu berücksichtigen, wurde in ISO 3664:2009 der UV-Spektralanteil der Leuchtstoffröhren erhöht. In der Praxis gibt es immer noch Abstimmungsplätze mit Leuchtstoffröhren nach ISO 3664:2000 mit geringerem spektralem UV-Anteil. Dies führt zu visuellen Abweichungen bei der Abstimmung.

Abstimmungsplatz im Drucksaal

Mediengestalterarbeitsplatz

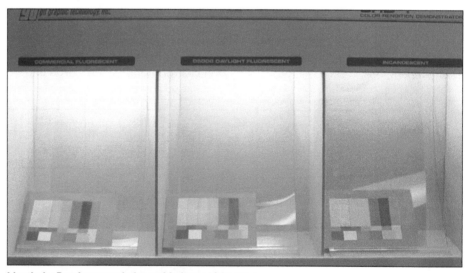

Identische Drucke unter drei verschiedenen Lichtarten
Links: Bürolicht – „Cool White Fluorescent"
Mitte: Normlichtart D50 gemäß ISO 3664
Rechts: Glühlampe

2.2 Farbmessung

2.2.1 Farbmetrik

In der Digitalfotografie und der nachfolgenden Medienproduktion kommt es darauf an, Farben messen und absolut kennzeichnen zu können. Sowohl das RGB-System wie auch das CMY- bzw. das CMYK-System erfüllen diese Forderung nicht. Die Farbdarstellung unterscheidet sich je nach Farbeinstellungen der Soft- und Hardware. Wir brauchen deshalb zur absoluten Farbkennzeichnung sogenannte prozessunabhängige Farbsysteme. In der Praxis sind zwei Systeme eingeführt: das CIE-Normvalenzsystem und das CIELAB-System. Beide Farbsysteme umfassen alle für den Menschen sichtbaren Farben.

Die farbmetrische Messung von Farben wird mit Spektralfotometern durchgeführt. Hierbei wird der visuelle Eindruck einer Farbe mit den Farbmaßzahlen des im Messgerät voreingestellten Farbordnungssystems dargestellt.

Körperfarbmessung

Jedes Spektralfotometer zur Messung von Körperfarben, z.B. von Drucken, hat eine Lichtquelle, die das gesamte sichtbare Spektrum emittiert. Ihre spektrale Strahlungsverteilung wird auf Idealweiß und auf die Strahlungsverteilung der einzelnen Normlichtarten bzw. Glühlampenlicht bezogen.

Messbedingungen nach ISO 13655:2009

In der Norm ISO 13655:2009 sind vier Messbedingungen für die spektralfotometrische Aufsichtsmessung definiert. Im Color Management ist die Messbedingung M1 Standard mit Lichtart D 50 und 2° Messwinkel.

- *Messbedingung* M0
 Lichtart A, der UV-Anteil ist nicht definiert, für Papiere ohne optischen Aufheller, entspricht der bisherigen

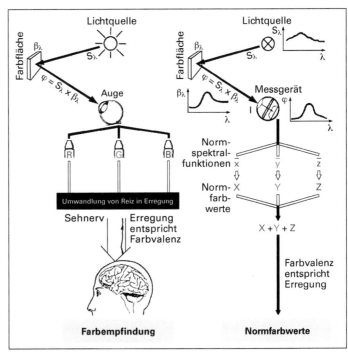

Vergleich von Farbensehen und Farbmetrik

spektralfotometrischen Messung und ist bei älteren Messgeräten noch Praxis.

- *Messbedingung* M1
 Lichtart D50, definierter UV-Anteil, kein Polfilter, für Papiere und Farbstoffe mit Fluoreszenz (OBA). Optische Aufheller(OBA, Optical Brightener Agents) sind chemische Stoffe, die Licht im ultravioletten und violetten Bereich (ca. 340-370 nm) des Spektrums absorbieren und die Strahlung im Blaubereich (ca. 420-470 nm) wieder emittieren. Papiere mit optischen Aufhellern erscheinen dadurch visuell heller und weißer.
- *Messbedingung* M2
 Keine definierte Lichtart, kein UV-Anteil (UV-Cut)
- *Messbedingung* M3
 Keine definierte Lichtart, kein UV-Anteil (UV-Cut), Polarisationsfilter

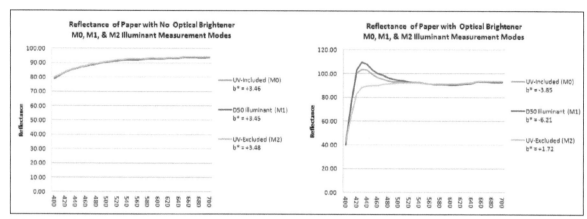

Beleuchtungsbedingungen

Drei verschiedene Beleuchtungen auf das gleiche Papier mit und ohne optischen Aufheller

Lichtfarbmessung

Spektralfotometer zur Lichtfarbmessung haben keine eigene Lichtquelle. Bei Geräten, die Körper- und Lichtfarbmessung ermöglichen, wird die interne Lichtquelle zur Lichtfarbmessung ausgeschaltet.

Messwerterfassung

Spektralfotometer erfassen die spektralen Anteile des Lichts über das gesamte sichtbare Spektrum. Grundsätzlich gibt es dazu zwei verschiedene technische Prinzipien. Beim ersten Bauprinzip wird das von der Probe remittierte oder emittierte Licht durch ein Beugungsgitter aufgeteilt. Das zweite Konstruktionsprinzip ist die Aufteilung des Lichts durch schmalbandige Farbfilter mit einer Schrittweite von z. B. 20 nm. Bei beiden Gerätetypen wird das Licht von Fotodioden erfasst und in elektrische Spannung umgewandelt. Die Signale werden zur weiteren Auswertung an den Rechner des Spektralfotometers bzw. an einen online verbundenen Computer weitergeleitet.

Making of …

1 Kalibrieren Sie das Spektralfotometer auf dem keramischen Weißstandard der Ladekonsole bzw. des Messtisches.

2 Stellen Sie Messmodus und Messbedingung ein.

3 Messen Sie die Farbe. Beachten Sie dabei die Vorgaben für die Unterlage der Probe:
 - weiße Unterlage für Proofs
 - schwarze Unterlage für den Fortdruck

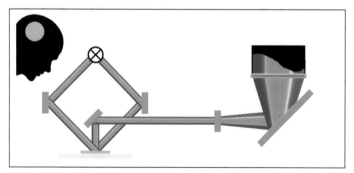

Messprinzip eines Spektralfotometers

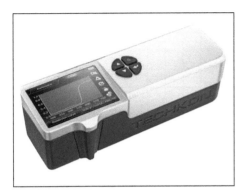

Handmessgerät – TECHKON SpectroDens
Farbmetrische Messung, z. B. Anzeige einer
Remissionskurve

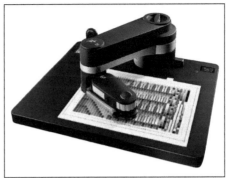

Automatikmessgerät – X-Rite i1iO
Spektralfotometrische Messung von Test-
formen, z. B. zur Ausgabeprofilerstellung

2.2.2 Densitometrie – Auflichtmessung nach DIN 16536

Die densitometrische Farbmessung un-
terscheidet sich grundsätzlich von der
spektralfotometrischen Farbmessung.
Aus der Messung können Sie keine
Farbmaßzahlen ableiten. Die Mess-
werte dienen zur Prozesskontrolle und
Prozesssteuerung im Druck.

Messprinzip
Bei der Aufsichtsmessung wird die Pro-
be von einer Lichtquelle im Densitome-
ter beleuchtet. Ein Teil des aufgestrahl-
ten Lichts I_0 wird absorbiert. Die übrige
Lichtintensität I_1 wird remittiert und von
einem Fotoempfänger erfasst.

Messanordnung
- *Messgeometrie*
 Die Messgeometrie ist 0/45 oder 45/0.
 Die erste Zahl bezeichnet den Licht-
 einfallswinkel, die zweite gibt den
 Messwinkel an. Durch die Messgeo-
 metrie soll die Glanzwirkung mini-
 miert werden.
- *Polarisationsfilter*
 Nasse Druckfarbe zeigt in der Mes-
 sung, trotz der angepassten Mess-
 geometrie, erhöhte Dichtewerte. Ein
 Polarisationsfilter im Strahlengang
 dient zur Ausschaltung des Glanzes

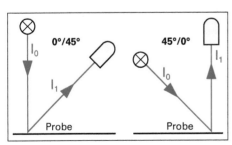

**Messgeometrien der densitometrischen Auf-
lichtmessung**

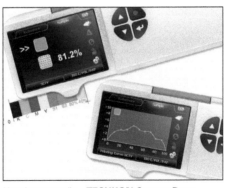

Handmessgerät – TECHKON SpectroDens
Densitometrische Messung, z. B. Anzeige des
Rastertonwerts

15

nasser Druckfarbe. Die Messungen mit Polarisationsfilter ergeben bei trockener und nasser Druckfarbe ähnliche Dichtewerte.

- *Lichtart*
 Die Probenbeleuchtung soll der Normlichtart A (2 856 K) entsprechen, die Lichtart der Messbedingung M0.
- *Messfeldgröße*
 Der Durchmesser der Messblende soll für eine Rasterweite von 60 L/cm 3,5 mm betragen.
- *Bezugsweiß*
 Als Bezugsweiß wird meistens das Papierweiß des unbedruckten Bogens genommen. Da fast alle Bedruckstoffe durchscheinend sind, wird grundsätzlich auf einer mattschwarzen Unterlage gemessen.

Rastermessung im Druck

Bei der Messung sind die geometrische und die optisch wirksame Flächendeckung nicht gleich. Der so genannte Lichtfang führt zu einer optischen Tonwertzunahme des Rastertonwerts. Verantwortlich dafür ist die Reflexion und diffuse Streuung des aufgestrahlten Lichts am Rand der Rasterelemente. Die wirksame Flächendeckung im Druck wird mit der Murray-Davies-Formel berechnet.

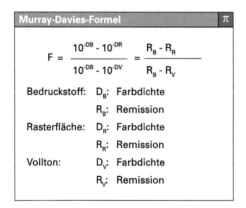

Murray-Davies-Formel	π

$$F = \frac{10^{-DB} - 10^{-DR}}{10^{-DB} - 10^{-DV}} = \frac{R_B - R_R}{R_B - R_V}$$

Bedruckstoff: D_B: Farbdichte

R_B: Remission

Rasterfläche: D_R: Farbdichte

R_R: Remission

Vollton: D_V: Farbdichte

R_V: Remission

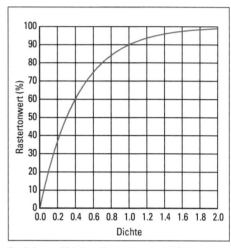

Beziehung Dichte – Rastertonwert (%)

Making of …

1 Kalibrieren Sie das Densitometer auf Papierweiß.

2 Stellen Sie Messmodus und Messbedingung ein.

3 Messen Sie die Rasterfläche. Beachten Sie dabei die Vorgaben für die Unterlage der Probe.

Farbdichtemessung im Druck

Die Farbdichte steht in einem linearen Verhältnis zur Farbschichtdicke. Somit kann die Kontrolle und Steuerung der Farbführung in der Druckmaschine densitometrisch gestützt durchgeführt werden.

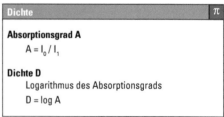

Dichte	π

Absorptionsgrad A

$A = I_0 / I_1$

Dichte D

Logarithmus des Absorptionsgrads

$D = \log A$

2.3 Farbmischungen

2.3.1 Additive Farbmischung – physiologische Farbmischung

Bei der additiven Farbmischung wird Lichtenergie verschiedener Spektralbereiche addiert. Die Mischfarbe (Lichtfarbe) enthält also mehr Licht als die Ausgangsfarben. Sie ist somit immer heller. Wenn Sie rotes, grünes und blaues Licht mischen, dann entsteht durch die Addition der drei Spektralbereiche das komplette sichtbare Spektrum, d. h. Weiß.

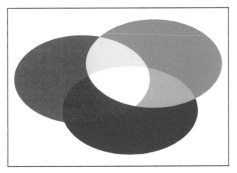

Additive Farbmischung

Beispiele für die Anwendung der additiven Farbmischung sind der Monitor, die Digitalkamera, die Bühnenbeleuchtung und die Addition der drei Teilreize (Farbvalenzen) beim menschlichen Farbensehen. Man nennt deshalb die additive Farbmischung auch physiologische Farbmischung.

2.3.2 Subtraktive Farbmischung – physikalische Farbmischung

Bei der subtraktiven Farbmischung wird Lichtenergie subtrahiert. Jede hinzukommende Farbe absorbiert einen weiteren Teil des Spektrums. Die Mischfarbe (Körperfarbe) ist deshalb immer dunkler als die jeweiligen Ausgangsfarben der Mischung. Schwarz als Mischung der subtraktiven 3 Grundfarben Cyan, Magenta und Gelb absorbiert das gesamte sichtbare Spektrum.

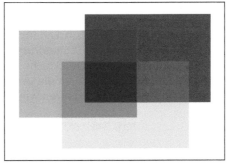

Subtraktive Farbmischung

Beispiele für die Anwendung in der Praxis sind der Farbdruck und künstlerische Mal- und Zeichentechniken. Da diese Farbmischungen, unabhängig vom menschlichen Farbensehen, technisch stattfinden, nennt man die subtraktive Farbmischung auch physikalische Farbmischung.

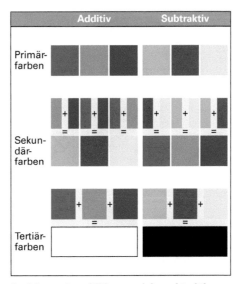

Beziehung der additiven und der subtraktiven Farbmischung

2.3.3 Autotypische Farbmischung – Farbmischung im Druck

Die Mischung der Farben im Druck wird allgemein als autotypische Farbmischung bezeichnet. Ihre Gesetzmäßigkeiten gelten grundsätzlich für alle Druckverfahren, vom Digitaldruck bis hin zu künstlerischen Drucktechniken wie der Serigrafie. Auch die verschiedenen Rasterungsverfahren wie amplituden- und frequenzmodulierte Rasterung erzielen die Farbwirkung durch diese Farbmischung.

Die autotypische Farbmischung vereinigt die additive und die subtraktive Farbmischung. Voraussetzung für die farbliche Wirkung der Mischung ist allerdings, dass die Größe der gedruckten Farbflächen bzw. Rasterelemente unterhalb des Auflösungsvermögens des menschlichen Auges liegt. Die zweite Bedingung ist, dass die verwendeten Druckfarben lasierend sind. Die zuoberst gedruckte Farbe deckt die darunterliegende nicht vollständig ab, sondern lässt sie durchscheinen. Das remittierte Licht der nebeneinander liegenden Farbflächen mischt sich dann additiv im Auge (physiologisch), die übereinander gedruckten Flächenelemente mischen sich subtraktiv auf dem Bedruckstoff (physikalisch).

Autotypische Farbmischung

Durch den groben Raster sehen Sie die einzelnen Rasterpunkte. Vergößern Sie den Betrachtungsabstand – die Farben mischen sich autotypisch zu einem Gesamtbild.

Schematische Darstellung der Farbmischung im Druck

Die lasierenden Druckfarben transmittieren ihre Lichtfarben und absorbieren ihre Komplementärfarbe.
Der Bedruckstoff remittiert die Lichtfarben. Diese werden im Auge additiv zum Farbeindruck der Körperfarbe gemischt.

2.4 Farbordnungssysteme

2.4.1 Einteilung

Es gibt Dutzende Farbordnungssysteme mit ganz unterschiedlichen Ordnungs-kriterien. Die in der Medienproduktion gebräuchlichsten Systeme werden im Folgenden vorgestellt.

Farbmischsysteme
Farbmischsysteme orientieren sich an herstellungstechnischen Kriterien. Bei-spiele hierfür sind das System Itten und Hickethier, aber auch das RGB-System und das CMYK-System.

Farbauswahlsysteme
Aus den Farben eines Bildes werden bestimmte Farben ausgewählt und in eine Farbpalette/Farbtabelle übertra-gen. Ein indiziertes Farbbild basiert auf einer Farbtabelle mit maximal 256 Far-ben. Diese Auswahl ist nicht genormt, sondern systembedingt verschieden.

Farbmaßsysteme
Farbmaßsysteme basieren auf der valenzmetrischen Messung von Farben. Sie unterscheiden sich damit grundsätz-lich von den Farbmischsystemen. Als Beispiele wären das CIE-Normvalenz-system, das CIELAB-System und das CIELUV-System zu nennen.

2.4.2 Sechsteiliger Farbkreis

Das einfachste Farbordnungssystem ist der sechsteilige Farbkreis. Die 3 Grundfarben der additiven Farbmi-schung (RGB) und die 3 Grundfarben der subtraktiven Farbmischung (CMY) sind immer abwechselnd, entsprechend den Farbmischgesetzen, angeordnet.

Magenta ist als einzige Grundfarbe nicht im Spektrum vertreten. Sie ist die additive Mischung aus den beiden Enden des Spektrums Blau und Rot.

Durch die Kreisform wird das Spektrum geschlossen.

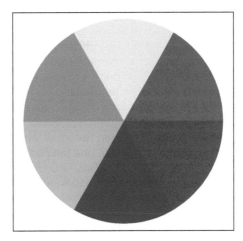

Sechsteiliger Farbkreis

Komplementärfarben
Komplementärfarben sind Farbenpaare, die in einer besonderen Beziehung zueinander stehen:
- Komplementärfarben liegen sich im Farbkreis gegenüber.
- Komplementärfarben ergänzen sich zu Unbunt.
- Komplementärfarbe zu einer Grund-farbe ist immer die Mischfarbe der beiden anderen Grundfarben.

In der Praxis werden zur Farbtrennung in digitalen Fotokameras, Videoka-meras und Scannern Komplementär-filter eingesetzt. In der Gestaltung ist der Komplementärkontrast einer der wichtigsten und häufig angewandten Kontraste.

Komplement
lat. Ergänzung

Additiv:
Mischung bzw. Ergänzung zu Weiß

Subtraktiv:
Mischung bzw. Ergänzung zu Schwarz

2.4.3 RGB-System

Das RGB-System basiert auf der additiven Farbmischung. In der additiven Farbmischung werden die Grundfarben Rot, Grün und Blau als Lichtfarben gemischt. Diese Farben entsprechen der Farbempfindlichkeit der drei Zapfenarten des menschlichen Auges.

Die Farben werden im RGB-System durch drei Farbwerte definiert. Ein Farbwert bezeichnet den Rotanteil, ein Farbwert den Grünanteil und ein Farbwert den Blauanteil. Für Rot, Grün und Blau gibt es jeweils 256 Abstufungen: von 0 (keine Farbe) bis 255 (volle Intensität). Schwarz wird dementsprechend im RGB-System mit Rot: 0, Grün: 0 und Blau: 0 erzeugt. Die Darstellung von Rot

erreichen Sie mit den Farbwerten Rot: 255, Grün: 0 und Blau: 0. Da jeder der 256 Rotwerte mit jedem der 256 Grün- und 256 Blauwerte kombiniert werden kann, sind im RGB-System 16.777.216 Farben darstellbar.

Die technische Wiedergabe der Farben ist von den Softwareeinstellungen und den Hardwarekomponenten abhängig. Dadurch können sich die Farben bei den gleichen RGB-Farbwerten in der Monitordarstellung und der Beamerprojektion teilweise stark unterscheiden.

Farbmodus
Der Farbmodus gibt an, nach welchem Farbmodell die Farben eines digitalen Bildes aufgebaut sind. RGB-Modus bedeutet, dass die Farbinformation eines Pixels in den drei Farbkanälen Rot, Grün und Blau aufgeteilt ist. Bilder aus der Digitalfotografie, aber auch gescannte Bilder sind meist im RGB-Modus abgespeichert. Der RGB-Modus ist Standard in der medienneutralen Medienproduktion. Dabei müssen Sie den jeweiligen durch Farbprofile festgelegten RGB-Arbeitsfarbraum beachten.

RGB-Farbraum

Die Farbwerte bezeichnen die Eckpunkte.

255 maximaler Farbanteil
0 kein Farbanteil, d. h. kein Licht

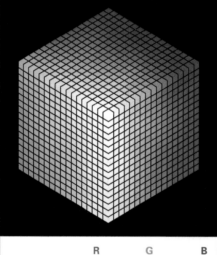

	R	G	B
Rot	255	0	0
Grün	0	255	0
Blau	0	0	255
Cyan	0	255	255
Magenta	255	0	255
Gelb	255	255	0
Weiß	255	255	255
Schwarz	0	0	0

Farbkanäle einer Bilddatei

Farbtiefe, Bittiefe, Datentiefe

Mit der Farbtiefe wird die Anzahl der möglichen Ton- bzw. Farbwerte eines digitalen Bildes, Videos oder einer Grafik bezeichnet. Sie wird in Bit/Kanal angegeben. Dabei gilt die Regel, dass mit n Bit 2^n Informationen bzw. Farben dargestellt werden können. Eine RGB-Datei mit 24 Bit Farbtiefe (8 Bit x 3 Kanäle) kann also 2^{24} = 16.777.216 Farben enthalten.

Farbtiefe/Kanal	Anzahl der Farben
1 Bit = 2^1	2
8 Bit = 2^8	256
10 Bit = 2^{10}	1 024
12 Bit = 2^{12}	4 096
16 Bit = 2^{16}	65 536
24 Bit = 2^{24}	16 777 216

In der Praxis werden für den Begriff Farbtiefe auch die beiden Begriffe Datentiefe und Bittiefe benutzt. Alle drei Begriffe sind synonym.

Farbwerte

Die RGB-Farbwerte werden durch den eingestellten Arbeitsfarbraum festgelegt. In der *Bibliothek der Mediengestaltung* ist es Adobe RGB (1998) **A**. Die Farbeinstellungen sind unter dem Namen BIME **B** für die Programme der Adobe CC synchronisiert.

RGB-Farbwähler in Photoshop

Farbeinstellungen in Photoshop

Menü: Bearbeiten > Farbeinstellungen...

21

Die Farbtafeln auf dieser Seite sollen Ihnen für die Bewertung und Definition eines Farbtons Hilfestellung geben. Die angegebenen Farbwerte sind RGB-Prozesswerte entsprechend dem in den Programmen von Adobe CC eingestellten Arbeitsfarbraum. Die visuellen Farbabweichungen sind durch die Separation der RGB-Datei in den CMYK-Modus des Drucks bedingt.

RGB-Farbtafeln

Beim Betrachten und Bewerten eines Farbfeldes sollten Sie dessen Umfeld mit einer Maske abdecken. Nur so können Sie verfälschende Effekte wie den Simultankontrast vermeiden.

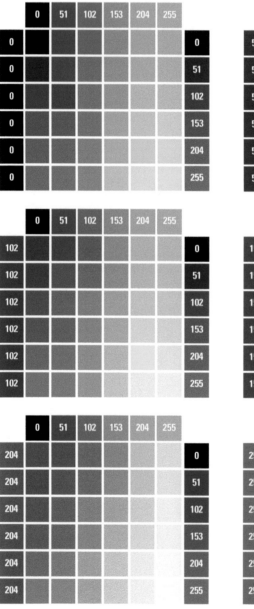

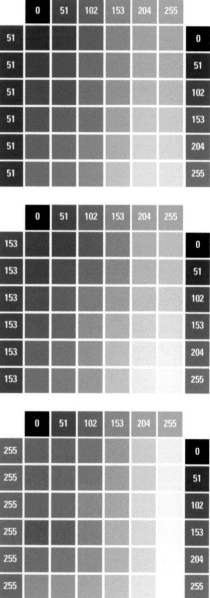

1	R :	166	2	R :	70
	G :	188		G :	91
	B :	211		B :	112
3	R :	13	4	R :	255
	G :	16		G :	255
	B :	24		B :	249
5	R :	100	6	R :	172
	G :	104		G :	186
	B :	65		B :	208
7	R :	36	8	R :	231
	G :	38		G :	148
	B :	42		B :	72
9	R :	134	10	R :	137
	G :	64		G :	86
	B :	46		B :	32

RGB-Farbwerte

1	R :	118	2	R :	49
	G :	126		G :	77
	B :	70		B :	54
3	R :	213	4	R :	150
	G :	161		G :	169
	B :	168		B :	97
5	R :	172	6	R :	45
	G :	135		G :	49
	B :	75		B :	51
7	R :	133	8	R :	246
	G :	141		G :	253
	B :	150		B :	254
9	R :	124	10	R :	60
	G :	130		G :	91
	B :	138		B :	53

RGB-Farbwerte

23

2.4.4 CMYK-System

Die Buchstaben CMY bezeichnen die Grundfarben der subtraktiven Farbmischung Cyan, Magenta und Gelb (Yellow). Beim Mehrfarbendruck wird zur Kontrastunterstützung noch zusätzlich Schwarz (BlacK oder Key) gedruckt. Die Koordinaten des Farbraums sind die Flächendeckungen, mit denen die Farben gedruckt werden.

Da ein Farbraum durch vier Grundfarben überbestimmt ist, muss bei jedem CMYK-Farbraum die Grundfarbe Schwarz definiert werden. Die eindeutigste Definition ergibt sich, wenn keine Mischfarbe durch mehr als drei Grundfarben entsteht, nämlich entweder durch drei Buntfarben (Buntauf-

bau) oder durch zwei Buntfarben und Schwarz (Unbuntaufbau).

Abhängig von der Separationsart, dem Papier und den Druckbedingungen ergeben sich andere farbmetrische Eckpunkte. Es gibt somit mindestens so viele CMYK-Farbräume, wie es unterschiedliche Kombinationen von Papier und Druckbedingungen gibt.

Spektrale Remission
Spektrale Remissionswerte geben Auskunft über die spektrale Zusammensetzung (Eigenschaft) einer Körperfarbe. Je höher der Remissionsgrad einzelner Wellenlängen ist, desto größer ist ihr Anteil an der Farbwirkung.

Körperfarben
Remission der Lichtgrundfarben Rot, Grün und Blau

Ideale Körperfarben
Die spektrale Remission der idealen Skalenfarben CMY unterscheidet sich erheblich von der spektralen Strahlungsverteilung der realen Farben. Bei den idealen Farben werden jeweils zwei Spektralbereiche remittiert, der dritte Spektralbereich (Komplementärfarbe) wird absorbiert. Die remittierten Lichtfarben liegen im 6-teiligen Farbkreis neben der jeweiligen Körperfarbe; die absorbierte Lichtfarbe liegt gegenüber.

Reale Körperfarben
Bei den realen Körperfarben wird die Komplementärfarbe nicht vollständig absorbiert, die Eigenfarben werden nicht vollständig remittiert. Diese Abweichung der Druckfarben von ihrer spektralen Idealfunktion führt ohne

CMYK-Farbraum
Die Farbwerte bezeichnen die Eckpunkte.

100 maximaler Farbanteil
0 kein Farbanteil, d. h. Papierweiß

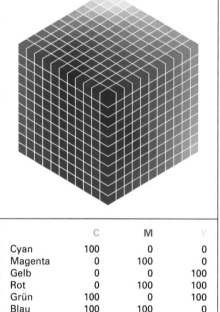

	C	M	Y
Cyan	100	0	0
Magenta	0	100	0
Gelb	0	0	100
Rot	0	100	100
Grün	100	0	100
Blau	100	100	0
Weiß	0	0	0
Schwarz	100	100	100

Basisfarbkorrektur bei der Separation zu einem farblich stark verfälschten Druckergebnis. Hervorgerufen wird dieser Farbfehler durch die Absorption der Nebenfarben und die Remission der additiven Komplementärfarbe. Die Nebenabsorption bewirkt, dass zu wenig Licht remittiert wird. Dadurch wirkt die Farbe dunkler, man spricht von Verschmutzung oder Verschwärzlichung der Farbe. Durch die Remission der Komplementärfarbe erscheint die Farbe heller, sie wird verweißlicht. Die Korrektur dieser spektralen Mängel erfolgt durch die Scan- oder Bildverarbeitungssoftware. Sie kann von Ihnen i.d.R. nicht beeinflusst werden, sondern läuft automatisch im Hintergrund ab.

Zur Berechnung ist in einer Farbtabelle, einer sogenannten Color-Look-up-Table (CLUT), die Idealfunktion hinterlegt. Beim Einsatz eines Color-Management-Systems sind die Korrekturtabellen im ICC-Profil integriert. Da in den einzelnen Programmen zur Medienproduktion nicht dieselben Algorithmen zur Berechnung der Farbkorrektur eingesetzt werden, führt die Basisfarbkorrektur zu jeweils unterschiedlichen Ergebnissen.

Ideal-Weiß

Der spektrale Remissionsgrad $R(\lambda)$ oder $\beta(\lambda)$ einer ideal-weißen Oberfläche, Weißstandard, ist für alle Wellenlängenbereiche des sichtbaren Spektrums ($\Delta\lambda$): 1,0 bzw. 100 %.

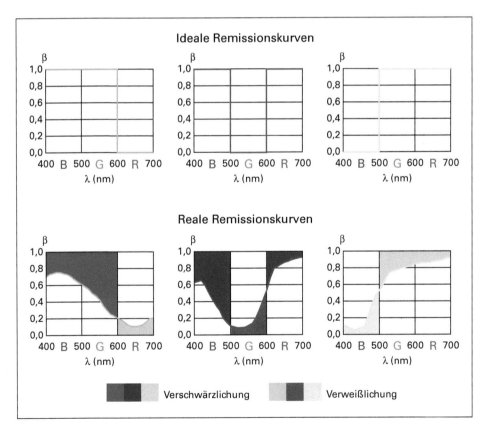

Ideale und reale Remission der Skalenfarben CMY

Graubalance

Die Graubalance, auch als Graubedingung oder Farbbalance bezeichnet, ist das gleichgewichtige Verhältnis der Druckfarben Cyan, Magenta und Gelb (Yellow).

Bedingt durch die spektralen Mängel ergeben gleichwertige Farbanteile von CMY kein neutrales, sondern ein farbstichiges Grau. Durch farblich gleichwertige Anteile von CMY wird die Graubedingung erfüllt.

Das menschliche Auge kann bei der visuellen Beurteilung im neutralen Bereich, von Weiß über Grau nach Schwarz, Farbabweichungen am besten erkennen. Neutrale Töne gelten deshalb als Indikator für die Farbbalance im Bild. Stimmt die Graubalance, dann stimmt auch das Verhältnis der Farben in den Buntfarbtönen.

Die Graubalance ist in verschiedenen Bereichen der Bildverarbeitung von Bedeutung:
- Festlegen der neutralen Töne beim Scannen und in der Bildverarbeitung
- Farbstichausgleich
- Einstellen der neutralen Töne bei der Bildschirmkalibrierung
- Anpassen der Bildschirmdarstellung an den Druck
- Separationseinstellung
- Kontrollfelder im Druckkontrollstreifen, das Rasterfeld CMY ergibt bei korrekten Druckbedingungen angenähert ein neutrales Grau.

Zur Einstellung der Graubalance in Photoshop muss in der Kanälepalette der Composite-Kanal ausgewählt sein.

Separation

Unter Farbseparation versteht man die Umrechnung der digitalen Bilddaten aus einem gegebenen Farbraum, z. B. RGB, in den CMYK-Farbraum des Mehrfarbendrucks.

Der farbige Druck basiert auf der subtraktiven Körperfarbmischung. Die Skalengrundfarben sind somit die drei subtraktiven Grundfarben Cyan, Magenta und Gelb (Yellow). Da diese drei Farben, bedingt durch spektrale Mängel, im Zusammendruck kein neutrales Schwarz ergeben, muss Schwarz als vierte Prozessdruckfarbe eingesetzt werden. Jede Farbe ist in einem Farbraum durch drei Koordinaten ausreichend definiert. Durch das Hinzukommen der vierten Farbe Schwarz ist der dreidimensionale Farbraum überbestimmt. Mit der Separation wird nun festgelegt, ob und mit welchem Anteil die Verschwärzlichung der Tertiärfarbe durch die Komplementärfarbe (Buntaufbau, UCR) oder durch Schwarz (Unbuntaufbau, GCR) erfolgt. Abhängig von der Separationsart, dem Papier und den

10	20	30	40	50	60	70	80	90	100

10	20	30	40	50	60	70	80	90	100
10	20	30	40	50	60	70	80	90	100

Farbstich durch falsche Graubalance
Die 10 %-Abstufung berücksichtigt nicht die unterschiedlichen spektralen Mängel von CMY.

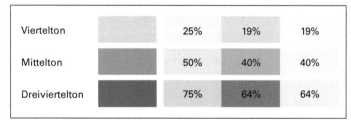

Viertelton		25%	19%	19%
Mittelton		50%	40%	40%
Dreiviertelton		75%	64%	64%

Graubalance nach DIN ISO 12647-2

Druckbedingungen ergeben sich andere farbmetrische Eckpunkte. Es gibt somit mindestens so viele CMYK-Farbräume, wie es unterschiedliche Kombinationen von Papier und Druckbedingungen gibt.

- *Unbuntaufbau – GCR, Gray Component Replacement*
Alle Farbtöne eines Bildes, die nicht nur aus zwei, sondern aus drei Grundfarben aufgebaut werden, enthalten einen Unbuntanteil. Dieser Unbuntanteil entspricht idealisiert dem Anteil der geringsten Buntfarbe in allen drei Buntfarbauszügen. Der Unbuntanteil wird in den Buntfarbauszügen abgezogen und zum Schwarz-Auszug addiert. Alle Tertiärfarben bestehen deshalb beim

maximalen Unbuntaufbau aus zwei Buntfarben und Schwarz.

- *Buntaufbau – UCR, Under Color Removal*
Bei der Farbtrennung werden schwarze Flächen im Bild in allen vier Farbauszügen mit Farbe belegt. Dies ergibt, bei 100% Flächendeckung pro Farbauszug, im Druck 400% Flächendeckung. Die maximale druckbare Flächendeckung liegt aber bei 280–320%. Deshalb werden die Buntfarben, die unter dem Schwarz liegen, reduziert. Schwarz dient im Buntaufbau nur zur Kontrastverstärkung in den Tiefen und den neutralen dunklen Bildbereichen ab den Dreivierteltönen.

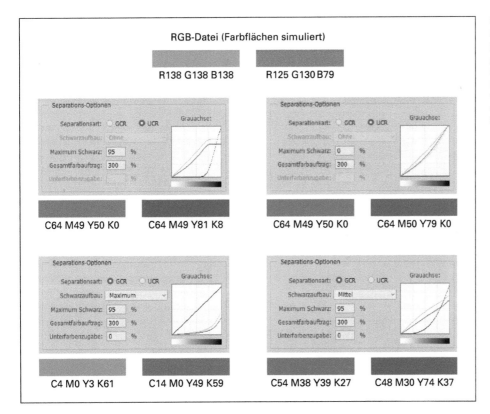

Separationsarten und -einstellungen

Die Farbflächen ergeben innerhalb der Druckprozesstoleranzen unabhängig von der Separationsart jeweils den gleichen Farbton.

Die Farbtafeln auf dieser Seite sollen Ihnen für die Bewertung und Definition eines Farbtons Hilfestellung ge- ben. Die angegebenen Farbwerte sind CMY-Prozesswerte entsprechend dem CMYK-Arbeitsfarbraum (Seite 21).

CMY-Farbtafeln

Beim Betrachten und Bewerten eines Farbfeldes sollten Sie dessen Umfeld mit einer Maske abdecken. Nur so können Sie verfälschende Effekte wie den Simultankontrast vermeiden.

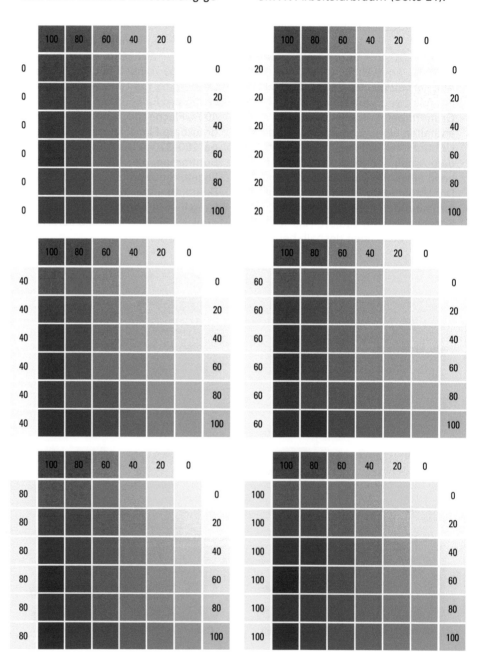

28

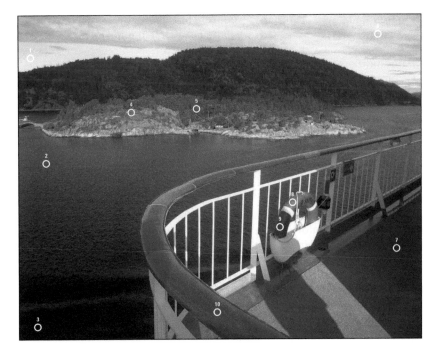

1	C : M : Y : K :	42% 16% 10% 2%	2	C : M : Y : K :	73% 43% 27% 38%
3	C : M : Y : K :	82% 69% 49% 89%	4	C : M : Y : K :	0% 0% 4% 0%
5	C : M : Y : K :	48% 31% 73% 45%	6	C : M : Y : K :	38% 19% 10% 2%
7	C : M : Y : K :	73% 60% 50% 78%	8	C : M : Y : K :	0% 51% 80% 0%
9	C : M : Y : K :	16% 78% 78% 35%	10	C : M : Y : K :	13% 60% 92% 39%

CMYK-Farbwerte

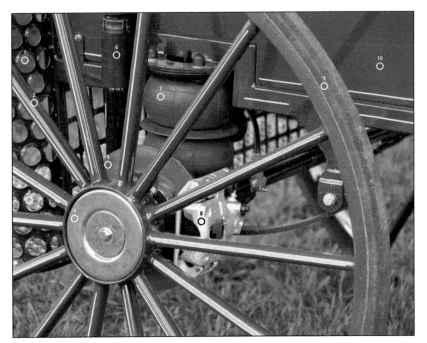

1	C : M : Y : K :	47% 22% 77% 34%	2	C : M : Y : K :	79% 27% 74% 60%
3	C : M : Y : K :	7% 45% 23% 1%	4	C : M : Y : K :	46% 11% 73% 11%
5	C : M : Y : K :	16% 41% 75% 20%	6	C : M : Y : K :	71% 54% 51% 71%
7	C : M : Y : K :	47% 31% 27% 18%	8	C : M : Y : K :	4% 0% 1% 0%
9	C : M : Y : K :	49% 35% 29% 23%	10	C : M : Y : K :	77% 22% 84% 51%

CMYK-Farbwerte

29

2.4.5 Farbauswahlsysteme – indizierte Farben

Das System der indizierten Farben ist weder ein Farbmischsystem noch ein Farbmaßsystem. Es ist ein Farbauswahlsystem.

Ein indiziertes Farbbild basiert auf einer Farbtabelle mit maximal 256 Farben. Wegen der Beschränkung auf 256 Farben eignen sich indizierte Farben nicht für Fotos oder andere Vorlagen mit vielen Farben. Für Pixelgrafiken mit weniger als 256 Farben ist die Indizierung gut geeignet. Die Farbinformation ist in einem Farbkanal gespeichert. Dies hat den Vorteil, dass indizierte Farbdateien kleine Dateigrößen haben. Grafiken mit weniger als 255 Farben können Sie mit der tatsächlichen Far-

benzahl speichern. Sie erzielen damit glatte Farbflächen und kleinere Dateigrößen.

Indizierte Bilddateien speichern

Um Pixelgrafiken in den Dateiformaten PNG-8 oder GIF zu speichern, bietet Photoshop mehrere Möglichkeiten. Die altbekannte Option ist Menü *Datei > Exportieren > Für Web speichern (Legacy)…* Der Begriff Legacy (dt. Erbe) zeigt an, dass diese Option von Adobe zwar noch unterstützt, aber nicht mehr weiterentwickelt wird. Aktuell sind die Optionen Menü *Datei > Exportieren > Schnell-Export als* oder Menü *Datei > Exportieren > Exportieren als…* die Funktionen, um Bilddateien für Digitalmedien zu optimieren und zu speichern.

Indizierte Bilddatei speichern

Photoshop: Menü *Datei > Exportieren > Für Web speichern (Legacy)…*

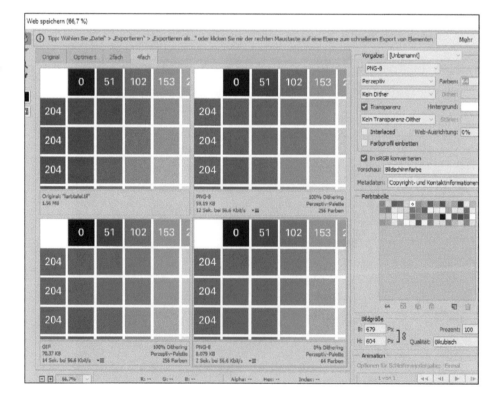

2.4.6 CIE-Normvalenzsystem

1931 wurde das Normvalenzsystem von der CIE, Commission Internationale de l´Eclairage, als eine der ersten internationalen Normen eingeführt. Das Farbsystem beruht auf der Farbe als menschlichem Gesichtssinn. In verschiedenen Versuchsreihen wurden in visuellen Experimenten mit Versuchspersonen die Farbvalenzen X, Y und Z für Rot, Grün und Blau der einzelnen Wellenlängen des sichtbaren Spektrums zahlenmäßig erfasst. Die Zahlenwerte wurden gemittelt und bilden als Normvalenzen eines sogenannten Normalbeobachters die Basis aller weiteren farbmetrischen Systeme. Um die Farbvalenzen grafisch umsetzen zu können, erfolgte die Umrechnung der Farbvalenzen in die Normspektralwertanteile x(λ), y(λ) und z(λ). Da die Summe der Normspektralwertanteile für jede Wellenlänge des Spektrums immer 1 ergibt, genügen x(λ) und y(λ), um alle Farben in eine Farbtafel eintragen zu können. Der Normspektalwertanteil z(λ) ist als fehlende Ergänzung zu 1 jeweils leicht zu errechnen. Die Senkrechte im Farbraum bildet die Helligkeit Y. Der Farbwert Y wird gleich der Helligkeit Y gesetzt, weil der Verlauf der spektralen Helligkeit zur Größe des Farbreizes für Grün proportional ist.

Beschreibung

- Im Normfarbraum sind alle sichtbaren Farben wiedergegeben.
- Die Spektralfarben (gesättigte Farben) liegen auf der unteren gekrümmten Außenlinie.
- Auf der unteren Geraden liegen die gesättigten Purpurfarben (additive Mischfarben aus Blau und Rot).
- Im Unbuntpunkt E (x = y = z = 0,33) steht senkrecht die Grauachse (Unbuntachse), Hellbezugswert Y = 0: Schwarz, Y = 100: Weiß.
- Additive Mischfarben liegen auf der Geraden zwischen den beiden Ausgangsfarben.

Farbortbestimmung

Zur Bestimmung des Farbortes einer Farbe genügen drei Kenngrößen:
- *Farbton* T
 Lage auf der Außenlinie
- *Sättigung* S
 Entfernung von der Außenlinie
- *Helligkeit* Y
 Ebene im Farbkörper

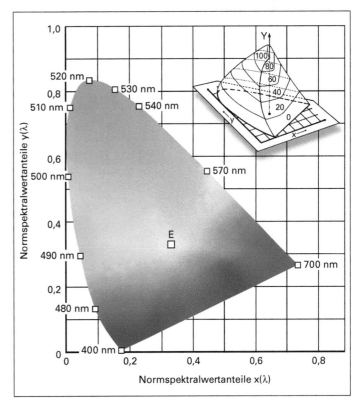

CIE-Normvalenzsystem

Normfarbtafel mit der Darstellung des Farbraums nach Rösch. Die Farbtafel zeigt die Luftaufnahme des Farbraums.

2.4.7 CIELAB-System

Der amerikanische Physiker David L. MacAdam untersuchte die Beziehung zwischen dem visuellen und dem geometrischen Farbabstand im CIE-Normvalenzsystem. Er fand dabei heraus, dass Farben, die empfindungsgemäß nicht zu unterscheiden sind, im Blaubereich nur einen verhältnismäßig kleinen geometrischen Abstand aufweisen. Im Grünbereich erscheinen dagegen auch geometrisch weit entfernte Farben gleich. Die sogenannten MacAdam-Ellipsen veranschaulichen dies. Alle innerhalb einer Ellipse liegenden Farben

sind visuell nicht zu unterscheiden. Die CIE führte 1976 einen neuen Farbraum ein. Im CIELAB-Farbsystem sind die beschriebenen Mängel des Normvalenzsystems durch eine mathematische Transformation behoben.

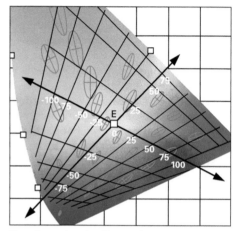

Transformation des Normvalenzsystems in das LAB-System

Die Transformation streckt den blauen Bereich und staucht den grünen Bereich des Normvalenzsystems. Der rote Bereich bleibt in etwa erhalten. Auch der Nullpunkt wurde verändert. Er ist jetzt im Zentrum des Farbraums, dem Unbuntpunkt E des Normvalenzsystems. Der Nullpunkt definiert jetzt die Grau- bzw. Unbuntachse. Die Farbebene wird meist als Quadrat oder Kreis dargestellt. Durch die Transformation wurde erreicht, dass die empfindungsgemäße und die geometrische Abständigkeit zweier Farben im gesamten Farbraum annähernd gleich sind. 1994 und 2000 wurden Weiterentwicklungen des LAB-Systems vorgestellt. Beide Systeme sollen eine bessere Anpassung an die Gleichabständigkeit in den Farbbereichen gewährleisten. In der Praxis haben sich beide Systeme je-

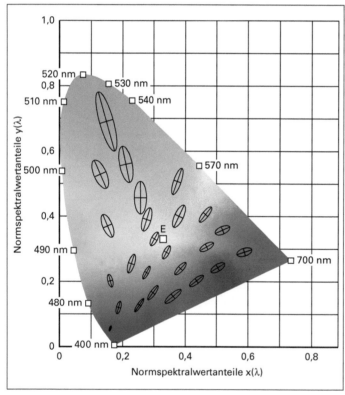

Normvalenzsystem mit MacAdam-Ellipsen

Die Farben innerhalb der MacAdam-Ellipsen sind empfindungsgemäß gleich.

doch nicht durchgesetzt. Das 1976-Modell ist nach wie vor das geltende Referenzmodell der Medienproduktion.

Beschreibung

- Im L*a*b*-Farbraum sind alle sichtbaren Farben wiedergegeben.
- Die Abbildung stellt das Innere des Farbraums dar.
- Die gesättigten Farben (Spektral- und Purpurfarben) liegen auf der Außenlinie der mittleren Ebene (L* = 50).
- In der Mitte des Farbraums steht senkrecht die Unbunt- bzw. Grauachse (a* = b* = 0; L* = 0: Schwarz, L* = 100: Weiß).

Farbortbestimmung

Zur Bestimmung des Farbortes einer Farbe genügen drei Kenngrößen:

- *Helligkeit* L* (Luminanz)
 Ebene im Farbkörper
- *Sättigung* C* (Chroma)
 Entfernung vom Unbuntpunkt
- *Farbton* H* (Hue)
 Richtung vom Unbuntpunkt

H* und C* werden auf zweierlei Arten beschrieben:

- Durch die Koordinaten a* und b* in der Farbebene
- Durch den Bunttonbeitrag ΔH*ab (Bunttonwinkel h*, a* = 0°, mathematisch positive Richtung) und den Buntheitsbeitrag ΔC*ab

Farbabstand ΔE*

Eine wichtige Aufgabe der Farbmetrik besteht darin, den visuellen Sinneseindruck Farbe messtechnisch erfassbar zu machen. Im LAB-System entsprechen sich der visuelle Abstand und der geometrische Abstand zweier Farben. Der Farbabstand ΔE* ist die Strecke zwischen zwei Farborten im Farbraum.

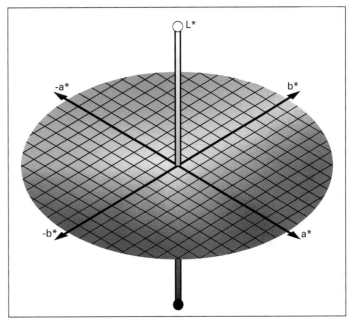

Berechnung von ΔE*

Die Berechnung des Farbabstandes erfolgt nach dem Satz des Pythagoras:
$c^2 = a^2 + b^2$.

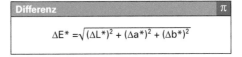

Differenz	π
$\Delta E^* = \sqrt{(\Delta L^*)^2 + (\Delta a^*)^2 + (\Delta b^*)^2}$	

Der ΔE*-Wert reicht zur Bewertung des Farbunterschiedes allein nicht aus. Zur genauen Beurteilung müssen Sie zusätzlich die Differenz der anderen Kenngrößen betrachten. Der Vergleichswert ist die Differenz zwischen Probe (Istfarbe) und Bezug (Sollfarbe):

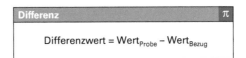

Differenz	π
Differenzwert = Wert$_{Probe}$ − Wert$_{Bezug}$	

CIELAB-System
Die Farbtafel zeigt den inneren Bereich der mittleren Ebene.
L* = 50
a*/–a*-Achse: Rot/Grün
b*/–b*-Achse: Gelb/Blau
Unbunt-, Grauachse:
a* = b* = 0
L* = 100 Weiß
L* = 0 Schwarz

Berechnung des Farbabstands ΔE*

Schritt 1:
Berechnung der Diagonalen in der Ebene a*/b*

$$c^2 = (\Delta a^*)^2 + (\Delta b^*)^2$$
$$c = \sqrt{(\Delta a^*)^2 + (\Delta b^*)^2}$$

Schritt 2:
Berechnung der Diagonalen im Quader

$$\Delta E^* = \sqrt{c^2 + (\Delta L^*)^2}$$

daraus folgt:

$$\Delta E^* = \sqrt{(\Delta a^*)^2 + (\Delta b^*)^2 + (\Delta L^*)^2}$$

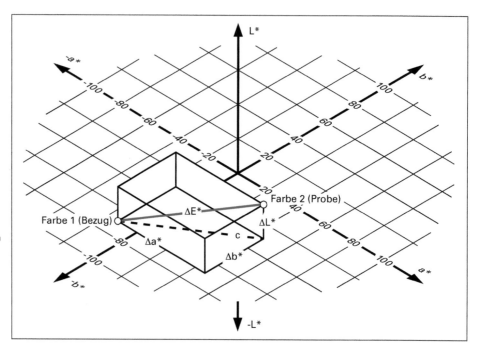

Visuelle Bewertung des Farbabstands ΔE*

Die Bewertung des Farbabstands ist vom jeweiligen Produkt abhängig. Sonderfarben im Verpackungsdruck bedingen allgemein engere Toleranzen als Abbildungen im 4c-Auflagendruck.
Die Bewertung durch Noten entspricht den üblichen Schulnoten.

Bei ΔL*, Δa*, Δb* zeigt das Vorzeichen die Richtung der Abweichung an.
Der Farbabstand ΔE* ist die Diagonale

Bewertung des Farbabstands		
Farbabstand ΔE*	Unterschieds-anteil	Note
1	unsicher erkennbar	1
2	erkennbar	2
4	mittlere Differenz	3
8	große Differenz	4
16	zu große Differenz	5

eines Quaders, der aus Δa*, Δb* und ΔL* gebildet wird.

LAB oder LCH?
Die Bewertung von Farben und die Bestimmung von Farbdifferenzen erfolgt meist im CIELAB-Farbraum über die Kenngrößen L*, a* und b*. Farbton H* und Sättigung S* werden dabei in der Ebene durch die Koordinaten a* und b* beschrieben. In der Bildverarbeitung ist es sinnvoller, die drei Größen L*, C* und H* unabhängig voneinander verändern zu können. Wir sprechen dann vom CIELCH-Farbraum. Dieser ist aber grundsätzlich identisch mit dem CIELAB-Farbraum. Der einzige Unterschied ist die Kennzeichnung des Farbortes in der Ebene.

Farbkorrektur im LAB-/LCH-Farbraum
Photoshop: Menü *Bild > Korrekturen > Farbton/Sättigung...*

2.5 Metamerie

Die Metamerie beschreibt das Phänomen, dass spektral unterschiedliche Farbreize die gleiche Farbempfindung auslösen. Die Transmissions- bzw. Remissionskurven der beiden zu vergleichenden Farben sind nicht gleich.
Der Farbreiz, d. h. das Produkt aus der spektralen Emissionsfunktion $S(\lambda)$ einer

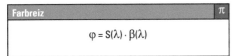

$$\varphi = S(\lambda) \cdot \beta(\lambda)$$

bestimmten Lichtquelle und den Transmissions- bzw. Remissionsfunktionen $T(\lambda)$, $R(\lambda)$ oder $\beta(\lambda)$ der Proben, hat aber denselben Wert. Die Flächen unter den Farbreizkurven beider Proben sind deshalb gleich. Daraus ergibt sich die gleiche Farbvalenz. Die beiden Farben sind visuell nicht unterscheidbar, sie sehen gleich aus. Ändert sich der Faktor Licht $S(\lambda)$, dann sind die Proben meist visuell wieder unterscheidbar.

Metamerie-Index
Der Farbabstand zwischen zwei Proben unter einer bestimmten Lichtquelle wird als Metamerie-Index MT bezeichnet. Die Metamerie zweier Farben ist umso ausgeprägter, je größer der Metamerie-Index, d. h. der Farbabstand nach dem Wechsel der Lichtart, ist.

Bedingt-gleiche oder metamere Farben
Bedingt-gleiche Farben sind zwei Proben, die unter einer bestimmten Beleuchtung einer Bezugslichtart (= Bedingung), z. B. D50, visuell nicht unterscheidbar sind, aber unterschiedliche spektrale Transmissions- bzw. Remissionskurven haben. Wenn Sie nun die beiden Proben unter einer veränderten Testlichtart, z. B. D65, betrachten, dann sind die Farben visuell unterschiedlich.

Ihr Metamerie-Index ist als Farbabstand messbar. Farben, deren Spektralkurven wenigstens zwei Kreuzungen aufweisen, sind meist metamer.

Unbedingt-gleiche Farben
Unbedingt-gleiche Farben sind Farben mit identischen Spektralfunktionen. Sie haben immer den Metamerie-Index MT = 0. Unbedingt-gleiche Farben sind unabhängig von der Beleuchtung visuell nie unterscheidbar.

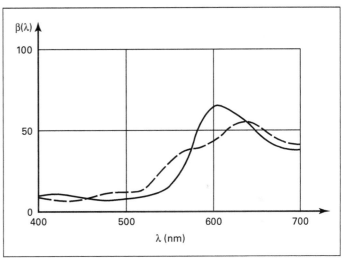

Remissionskurven zweier metamerer Farben

2.6 Aufgaben

1 Grundfarben digitaler Medien kennen

Nennen Sie die Grundfarben zur Darstellung von Farben auf einem Display.

2 Grundfarben des Drucks kennen

Nennen Sie die vier Grundfarben des Farbdrucks.

3 Farbkreis kennen

Benennen Sie die leeren Segmente im Farbkreis mit den entsprechenden Farbnamen.

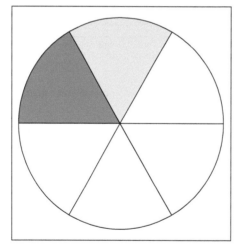

4 Farbsysteme kennen

a. Wie heißen die Grundfarben der additiven Farbmischung?
b. Warum wird die additive Farbmischung auch physiologische Farbmischung genannt?

a.

b.

5 Farbsysteme kennen

a. Wie heißen die Grundfarben der subtraktiven Farbmischung?
b. Warum wird die subtraktive Farbmischung auch physikalische Farbmischung genannt?

a.

b.

6 Farbsysteme kennen

Erläutern Sie den Begriff prozessunabhängiges Farbsystem.

7 Farbortbestimmung im Normvalenz-system kennen

Mit welchen Kenngrößen wird ein Farbort im CIE-Normvalenzsystem eindeutig bestimmt?

8 Farbortbestimmung im CIELAB-System kennen

Mit welchen Kenngrößen wird ein Farbort im CIELAB-System eindeutig bestimmt?

9 Arbeitsfarbraum erklären

Was ist ein Arbeitsfarbraum?

10 Farbabstand kennen

Was bezeichnet der Farbabstand ΔE^*?

11 Metamerie erklären

Was sind unbedingt-gleiche Farben?

12 Farbwiedergabe in einer Farbtafel

Nennen Sie drei Faktoren, die die Farbwiedergabe von Farbtönen einer Farbtafel beeinflussen.

1.

2.

3.

13 Metamerie erklären

Was sind bedingt-gleiche Farben?

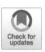

3.1 Wie viel CMYK ist Erdbeerrot?

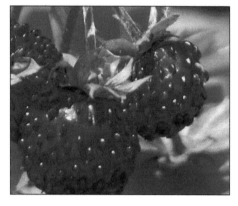

Sie fotografieren Walderdbeeren mit Ihrer Digitalkamera oder mit der Analogkamera auf ein bestimmtes Auf-nahmematerial. Das Bild soll in einem Bildverarbeitungsprogramm bearbeitet und dann z. B. in einem Buch über die Früchte des Waldes veröffentlicht werden.

Betrachten wir einmal den Workflow von der Aufnahmesituation bis hin zum fertigen Printprodukt unter dem Gesichtspunkt: Konsistenz der Farben. Konsistent kommt aus dem Lateinischen und bedeutet widerspruchsfrei, zusammenhängend. Bei der Verarbeitung von Farben heißt dies, dass z. B. die Farben Ihrer Erdbeeren im Druck gleich wirken wie die der Erdbeeren im Wald. Jede Station des Workflows, von der Bilddatenerfassung mit der

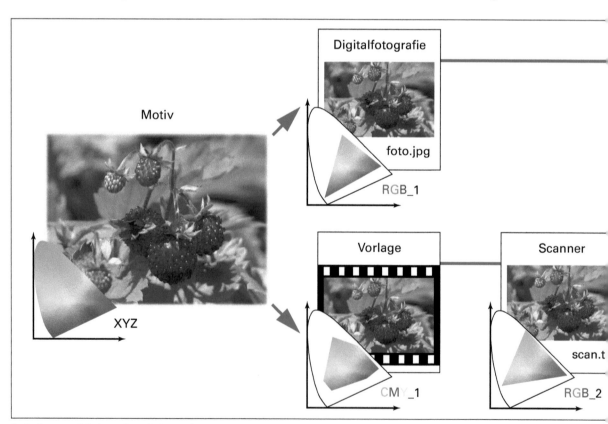

Farbräume und Farbmodi im Farbworkflow

© Springer-Verlag GmbH Deutschland 2018
P. Bühler, P. Schlaich, D. Sinner, *Digitale Farbe*, Bibliothek der Mediengestaltung,
https://doi.org/10.1007/978-3-662-54607-9_3

Kamera oder dem Scanner über die Verarbeitung im Computer mit entsprechender Software und die Darstellung auf dem Monitor bis hin zu Proof und Druck, erfordert eine systembedingte Transformation der Farben. Schon die Länge dieses Satzes zeigt die Komplexität des Workflows. Um der Forderung nach Konsistenz gerecht zu werden, muss die Art der Farbwiedergabe aller Systemkomponenten im Workflow bekannt sein und aufeinander abgestimmt werden. Hier setzt das Color Management an. In einem Color-Management-System, CMS, werden die einzelnen Systemkomponenten des Farbworkflows von der Bilddatenerfassung über die Farbverarbeitung bis hin zur Ausgabe in einem einheitlichen Standard erfasst, kontrolliert und abgestimmt. 1993 wurde dazu vom International Color Consortium, ICC, ein einheitlicher plattformunabhängiger Standard definiert. Das Ziel war die Schaffung einer einheitlichen farbmetrischen Referenz zur Farbdatenverarbeitung. Der ICC-Standard ist offen und steht allen Hard- und Softwareentwicklern zur Verfügung. Die Soft- und Hardwarekomponenten des Farbworkflows vom Bildverarbeitungs-, Grafik- und Layoutprogramm bis hin zum Monitor, Proofdrucker und den Druckverfahren sind Teil des Color-Management-Systems.

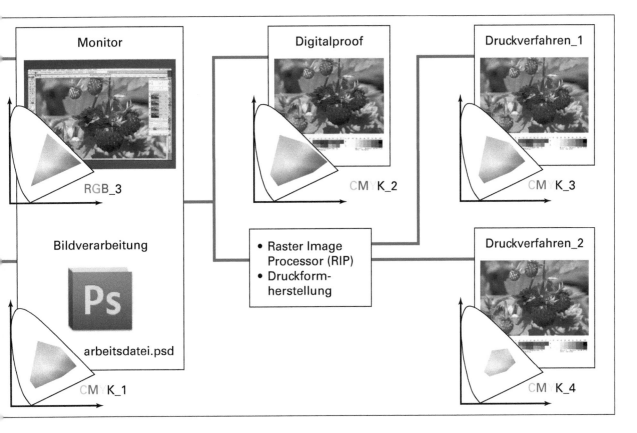

3.2 Profile Connection Space – PCS

In der Normvalenzfarbtafel (Yxy-Farbraum) sind alle Farbräume des Workflows der vorherigen Doppelseite zusammengefasst. Die Darstellung zeigt sehr deutlich die Notwendigkeit einer definierten Farbübertragung zwischen den einzelnen Stationen der Druckproduktion. Die Lösung des Problems ist ein gemeinsamer Referenzfarbraum. Dieser Farbraum muss so groß sein, dass alle Prozessfarbräume darin Platz finden. Außerdem müssen die Farborte messtechnisch farbmetrisch erfassbar und zahlenmäßig eindeutig definiert sein. Die XYZ-, Yxy- und LAB-Farbräu-

me erfüllen diese Forderungen. Sie umfassen alle sichtbaren Farben und somit automatisch alle Prozessfarbräume. Die Farborte sind eindeutig definiert und können in die jeweiligen Prozessfarbanteile, d.h. RGB bzw. CMYK, umgerechnet werden. In den Spezifikationen der ICC-Profile und des Gamut-Mappings wurden vom ICC und der ECI der XYZ- und der LAB-Farbraum als allgemein gültige Referenzfarbräume festgelegt. Da das Gamut-Mapping zwischen den Profilen in diesem Farbraum stattfindet, wird dieser auch als Profile Connection Space, PCS, bezeichnet.

Projektion der Prozessfarbräume

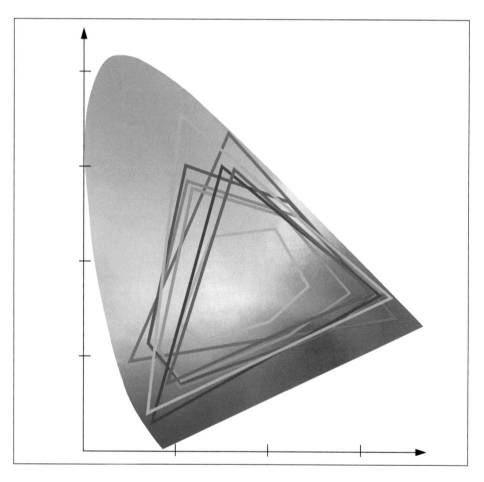

40

3.3 Farbprofile

Die Spezifikation der Farbcharakteristik eines Gerätes bzw. eines Ausgabeprozesses erfolgt durch sogenannte Farbprofile. Farbprofile sind Datentabellen, in denen die Farbcharakteristik bezogen auf definierte Referenzwerte beschrieben ist. Damit die Kompatibilität zwischen den einzelnen Komponenten des Farbworkflows gewährleistet ist, sind Inhalt und Struktur der Profile genormt.

3.3.1 ICC-Profile

1993 hat das ICC, International Color Consortium, ein Zusammenschluss führender Soft- und Hardwarehersteller unter der Federführung der Fogra, das plattformunabhängige ICC-Geräteprofil-Format festgelegt. ICC-Profile sind grundsätzlich unabhängig vom Erstellungsprogramm in jeder ICC-kompatiblen Software bzw. auf jedem ICC-kompatiblen Gerät einsetzbar. In der Praxis zeigt sich jedoch, dass sich die Profile abhängig von der Soft- und Hardware, die bei der Profilerstellung verwendet wurde, durchaus unterscheiden. Die Ergebnisse der Farbraumtransformation, des Gamut-Mappings, sind ebenfalls vom Color-Management-System abhängig. Daraus ergeben sich für Sie bestimmte Faktoren, die Sie bei der Erstellung und Anwendung von ICC-Profilen beachten sollten:

- Messgerät für die Farbwerterfassung
- Software zur Profilerstellung
- Einstellparameter bei der Profilerstellung
- CMM (Color Matching Modul), z. B. ColorSync oder Adobe CMM

```
ISO 28178
ORIGINATOR „Fogra, www.fogra.org, developed by GMG GmbH & Co. KG, Heidelberger Druckmaschinen
AG"
FILE_DESCRIPTOR „FOGRA51"
CREATED „May 2015"
INSTRUMENTATION „D50, 2 degree, geometry 45/0, no polarisation filter, white backing, according
to ISO 13655:2009 M1"
PRINT_CONDITIONS„Offset printing, according to ISO 12647-2:2013, OFCOM, print substrate 1 = pre-
mium coated, fluorescence moderate (8-14 DeltaB according to ISO 15397), 115 g/m2, tone value
increase curves A (CMYK)"
FILTER „M1"
POLARIZATION „none"
TARGET_TYPE „ISO12642-2"
KEYWORD „TARGET_LAYOUT"
TARGET_LAYOUT „visual"
NUMBER_OF_FIELDS 11
BEGIN_DATA_FORMAT
SAMPLE_ID CMYK_C CMYK_M CMYK_Y CMYK_K XYZ_X XYZ_Y XYZ_Z LAB_L LAB_A LAB_B
END_DATA_FORMAT
NUMBER_OF_SETS 1617

BEGIN_DATA
171        0.00 100.00  20.00   0.00 33.03 16.89 12.27 48.12 73.47   4.61
180       10.00 100.00  20.00   0.00 28.44 14.75 12.30 45.29 68.63  -0.38
189       20.00 100.00  20.00   0.00 24.27 12.86 12.28 42.55 63.34  -5.04
198       30.00 100.00  20.00   0.00 20.63 11.18 12.36 39.88 58.18  -9.88
207       40.00 100.00  20.00   0.00 17.36  9.69 12.45 37.28 52.69 -14.60
216       55.00 100.00  20.00   0.00 13.01  7.68 12.53 33.31 43.89 -21.69
```

ICC-Profil
FOGRA51 – PSO Coated v3 – Druckbedingung 1, premium gestrichenes Papier (ISO 12647-2:2013 PC 1)

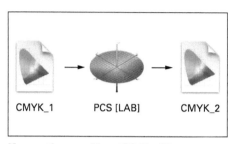

Konvertierung über ICC-Profil

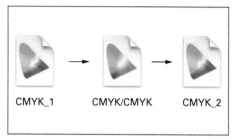

Konvertierung über Device-Link-Profil

3.3.2 RGB-Austauschprofile

Die medienneutrale Medienproduktion, vor allem im Bereich der Bildverarbeitung, findet meist in RGB statt. Ein wichtiges Kennzeichen der Austauschfarbräume ist ein großer Farbumfang. Damit ist gewährleistet, dass alle Dokumentfarben bei der Konvertierung in einen Ausgabefarbraum wiedergegeben werden können. Für die Konvertierung in einen Printfarbraum ist es außerdem wichtig, die visuelle Gleichabständigkeit zu erhalten und den Weißpunkt beizubehalten. In der Praxis werden

dazu meist *AdobeRGB* oder *eciRGB* als Arbeitsfarbraum genutzt. Das *eciRGB_v2-Profil* ist in der Norm ISO 22028 spezifiziert. Die Profildatei kann kostenlos von der Website der ECI, www.eci.org, heruntergeladen werden.

3.3.3 Device-Link-Profile

Mit Device-Link-Profilen transformieren Sie Profile direkt ohne die Zwischenstation PCS. Dies kann die Transformation von RGB nach RGB, von RGB nach CMYK oder auch direkt aus einem CMYK-Eingabefarbraum in einen CMYK-Ausgabefarbraum sein. Die direkte Konvertierung ist sinnvoll zum optimalen Datenaustausch zwischen verschiedenen Druckprozessen, zur Prozessanpassung innerhalb eines Druckprozesses oder als Möglichkeit zur Einsparung bunter Druckfarben durch die prozessoptimierte Separation. Die Farbraumtransformation mit Device-Link-Profilen bietet gegenüber der klassischen ICC-Farbraumtransformation über einen PCS einen wichtigen prozessbedingten Vorteil. Bei der Transformation einer separierten CMYK-Datei in den PCS gehen die Separationseinstellungen verloren. Die Ausgabe in einem anderen CMYK-Farbraum erfordert eine erneute Separation mit meist geänderten Einstellungen zum Schwarzaufbau. Dies kann dazu führen,

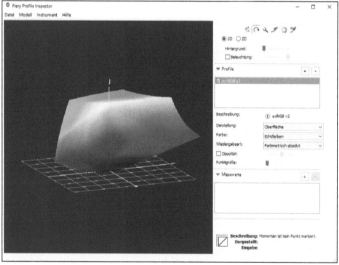

eciRGB_v2-Farbraum

dass schwarze Schrift oder schwarze Linien einer Vektorgrafik nicht mehr nur im Schwarz-Auszug mit 100 % Schwarz gedruckt werden, sondern nach den Regeln der Graubalance mit allen vier Skalenfarben.

eciCMYK (FOGRA53)

Medienneutrale Medienproduktion erfolgt üblicherweise als RGB-Workflow. Das eciCMYK-Profil der ECI ist ein CMYK-Austauschprofil mit dem CMYK-Austauschfarbraum FOGRA53 für die medienneutrale Printproduktion im CMYK-Modus. Da der Austauschfarbraum naturgemäß größer ist als der jeweilige Druckfarbraum, kann mit dem eciCMYK-Profil nicht direkt gedruckt werden. Damit bei einer Konvertierung die Separation mit dem Schwarzaufbau nicht verloren geht muss mit einem Device-Link konvertiert werden. Unter www.eci.org können Sie die entsprechenden Profile kostenlos herunterladen.

3.3.4 Profilklassen

Farbprofile werden nach ihrem Einsatzzweck in sieben Profilklassen eingeteilt.

- *Input-Device-Profile*
 Input-Device-Profile beschreiben die Transformation einer Datei aus dem Eingabefarbraum von Eingabegeräten wie Scanner und Digitalkameras in den geräteunabhängigen Profile Connection Space (PCS).
- *Display-Device-Profile*
 Mit diesen Profilen wird die Konvertierung aus dem PCS in den Gerätefarbraum von Geräten wie Monitoren und Beamern beschrieben.
- *Output-Device-Profile*
 Ausgabegeräte und Druckverfahren, die nach dem Prinzip der subtraktiven Farbmischung arbeiten, werden

Downloads

Offset Profile		
Neu: PSO SC-B Paper v3 pso_sc-b_paper_v3.zip	1376 KB	2017-08-27
PSO Coated v3 pso-coated_v3.zip	1784 KB	2015-09-30
PSO Uncoated v3 (FOGRA52) pso-uncoated_v3_fogra52.zip	1722 KB	2015-09-30
ISO Coated v2 to PSO Coated v3 (DeviceLink) iso-coated_v2_to_psocoated_v3_devicelink.zip	844 KB	2015-09-30
PSO Coated v3 to ISO Coated v2 (DeviceLink) pso-coated_v3_to_isocoated_v2_devicelink.zip	840 KB	2015-09-30
Tiefdruckprofile PSR_V2		
eci_gravure_psr_v2_2009.zip	3800 KB	2009-06-24/ 2009-12-30 (aktualisiert 2010-03-26)
RGB-Arbeitsfarbraum-Profil		
ecirgbv20.zip	4 KB	2007-04-16
CMYK-Austauschfarbraum-Profil		
Neu: eciCMYK ecicmyk.zip	1376 KB	2017-08-27
Neu: eciCMYK DeviceLink-Profile ecicmyk_devicelinkprofiles_2017-08-27.zip	27800 KB	2017-08-28

Hinweis: ECI-Profile sind nicht von der International Organization for Standardization (ISO) gefördert, offiziell anerkannt oder unterstützt, und sind möglicherweise nicht die einzigen ICC-Profile, die konform mit ISO-Standards sind.

Profil-Download www.eci.org

durch Output-Device-Profile charakterisiert. Die Profile beschreiben sowohl die Transformation aus dem PCS in den Geräte- bzw. Prozessfarbraum als auch vom Gerätefarbraum in den PCS.
- *Device-Link-Profile*
 Die direkte Transformation von einem Eingangsgerätefarbraum in einen Ausgangsgerätefarbraum ohne den Zwischenschritt PCS wird durch Device-Link-Profile beschrieben.
- *ColorSpace-Conversion-Profile*
 ColorSpace-Conversion-Profile beschreiben die Transformation einer

Datei von einem geräteunabhängigen Farbraum in den PCS und vom PCS in den geräteunabhängigen Farbraum.

- *Abstract-Profile*
 Profile dieser Profilklasse beschreiben die Konvertierung zwischen zwei Profile Connection Spaces, z. B. LAB und XYZ.
- *Named-Color-Profile*
 Konvertierung von Sonderfarben aus Farbskalen wie Pantone oder HKS in LAB oder Gerätefarbräume, z. B. CMYK.

3.3.5 FOGRA 51 und FOGRA 52

Es gibt neue Druckbedingungen nach ISO 12647-2:2013 für den Offsetdruck auf gestrichene und ungestrichene Premium-Papiere (PC1, PC5):

- FOGRA 51 (pso-coated_v3_.icc): Offset auf premium gestrichenem Papier Ablösung von FOGRA 39
- FOGRA 52 (pso-uncoated_v3.icc): Offset auf holzfrei ungestrichen weißem Papier Ablösung von FOGRA 47

Farbumfangvergleich a*, b*
FOGRA 53
FOGRA 52
FOGRA 51

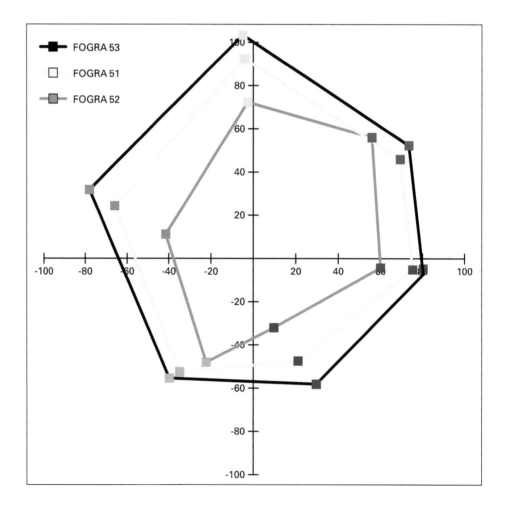

FOGRA 53	CMYK_C	CMYK_M	CMYK_Y	CMYK_K	LAB_L	LAB_A	LAB_B
Gelb	0	0	100	0	92.50	-4.88	103.33
Rot	0	100	100	0	47.00	73.42	52.23
Magenta	0	100	0	0	52.00	80.29	-7.37
Blau	100	100	0	0	23.00	29.64	-58.13
Cyan	100	0	0	0	51.00	-39.75	-55.44
Grün	100	0	100	0	49.50	-78.03	31.82
Weiß	0	0	0	0	96.50	1.00	-3.00
Schwarz	0	0	0	100	14.00	0.00	0.00
CMYK	100	100	100	100	4.71	-0.07	2.06

Profil FOGRA 53
Farbwerte der
Volltonfarben

FOGRA 51	CMYK_C	CMYK_M	CMYK_Y	CMYK_K	LAB_L	LAB_A	LAB_B
Gelb	0	0	100	0	88.94	-4.04	92.37
Rot	0	100	100	0	47.99	69.33	45.87
Magenta	0	100	0	0	48.06	75.29	-5.18
Blau	100	100	0	0	24.74	21.12	-47.45
Cyan	100	0	0	0	56.12	-34.90	-52.52
Grün	100	0	100	0	49.45	-65.93	24.34
Weiß	0	0	0	0	95.00	1.50	-6.00
Schwarz	0	0	0	100	16.00	0.07	-0.33
CMYK	100	100	100	100	12.71	0.53	4.89

Profil FOGRA 51
Farbwerte der
Volltonfarben

FOGRA 52	CMYK_C	CMYK_M	CMYK_Y	CMYK_K	LAB_L	LAB_A	LAB_B
Gelb	0	0	100	0	87.66	-2.65	72.38
Rot	0	100	100	0	52.59	55.96	55.96
Magenta	0	100	0	0	54.54	60.07	-4.30
Blau	100	100	0	0	38.47	9.76	-31.96
Cyan	100	0	0	0	58.70	-22.35	-48.12
Grün	100	0	100	0	51.97	-41.41	11.25
Weiß	0	0	0	0	93.50	2.50	-10.00
Schwarz	0	0	0	100	32.69	1.24	0.11
CMYK	100	100	100	100	26.36	1.50	1.35

Profil FOGRA 52
Farbwerte der
Volltonfarben

45

FOGRA 51-Profil
ISO 12647-2:2013

- Akzidenzoffset, premium gestrichenes Papier (Premium coated),
- Tonwertzunahmekurve 2013-A
- Schwarzlänge 9 (Einsatzpunkt 10%)
- Schwarzbreite 10
- max. Flächendeckung 300%
- max. Schwarz 96%

Schwarzlänge

Schwarzanteil über den gesamten Tonwertverlauf

Schwarzbreite

Schwarzanteil am reproduzierten Farbeindruck

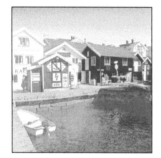

CMYK

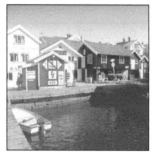

CMY

Cyan

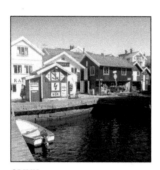

Magenta

Gelb (Yellow)

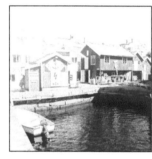

Schwarz (Key)

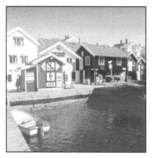

CM

CY

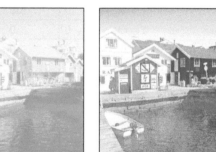

MY

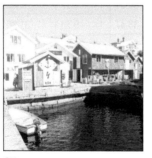

CK

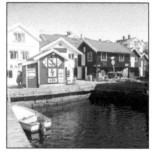

MK

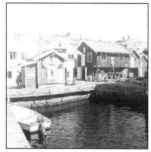

YK

46

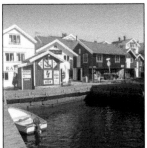

CMYK

CMY

Cyan

FOGRA 39-Profil
ISO 12647-2:2004

- Akzidenzoffset-
 druck, Papiertyp 1
 und 2
- glänzend oder matt
 gestrichen Bilder-
 druck
- Positivkopie
- Tonwertzunahme-
 kurven A (CMY)
 und B (K)
- Schwarzlänge 9
 (Einsatzpunkt 10%)
- Schwarzbreite 10
- max. Flächende-
 ckung 300%
- max. Schwarz 95%

Magenta

Gelb (Yellow)

Schwarz (Key)

CM

CY

MY

CK

MK

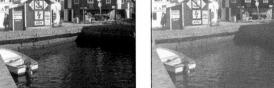

YK

47

3.3.6 ISO 12647:2013

Die Norm ISO 12647:2013 ist die neueste Revision der schon 1996 veröffentlichten Norm ISO 12647 zur Standardisierung des Drucks. Hauptgründe für die Revision sind eine Verbesserung der Prozesssteuerung beim Druck von optisch aufgehellten Papieren und eine bessere Übereinstimmung der messtechnischen und visuellen Bewertung von Proof und Druck.

Die ISO 12647 ist in acht Bereiche gegliedert:
- ISO 12647-1: Parameters and measurement methods (Definitionen und Messmethoden)
- ISO 12647-2: Offset lithographic processes (Offsetdruck)
- ISO 12647-3: Coldset offset lithography on newsprint (Zeitungsdruck)
- ISO 12647-4: Illustrationstiefdruck
- ISO 12647-5: Siebdruck
- ISO 12647-6: Flexodruck
- ISO 12647-7: Prüfdruck/Proof
- ISO 12647-8: Validation Print (Digitaldruck)

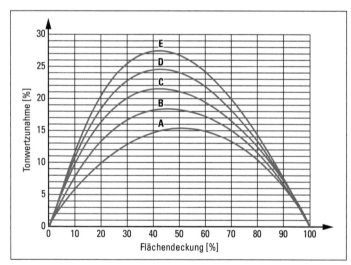

Tonwertzunahmekurven ISO 12647-2013

3.3.7 ISO 12647-2:2013

Die Norm ISO 12647-2 ist die Offsetdruck-Norm. Aus der Revision ergeben sich einige wichtige Veränderungen für die Praxis.

Druckbedingungen
Die bisherigen 5 Papiertypen wurden den Veränderungen des Marktes entsprechend auf 8 Bedruckstofftypen erweitert. Den 8 Bedruckstofftypen (Print Subtrate, PS) wurden jeweils Druckbedingungen (Printing Condition, PC) zugeordnet, 2 Bogen- und 6 Rollenoffsetdruckbedingungen. Für jeden Bedruckstoff werden die Druckbedingungen für die periodische, amplitudenmodulierte Rasterung, AM, und die nichtperiodische, frequenzmodulierte Rasterung, FM, in der Norm definiert. Daraus ergeben sich 16 Druckbedingungen.

Tonwertzunahme
In der bisherigen Norm ISO 12647-2:2004 waren die Tonwertzunahmekurven für die bunten Grundfarben, CMY, und für Schwarz, K, verschieden. Mit der Norm ISO 12647-2:2013 wurden die Tonwertkurven für alle vier Druckfarben, CMYK, modifiziert. Sie gelten jetzt für alle 4 Farben gleichermaßen. In der Übersicht auf den Seiten 50 und 51 sind für PC3, PC4, PC7 und PC8 zusätzlich noch die Werte von ISO 12647-2:2004 angegeben, da für diese Druckbedingungen noch die Profile auf der Basis von FOGRA 46, FOGRA 48 und FOGRA 42 zulässig sind.

Normlicht und Messtechnik
Die beiden Bereiche wurden ebenfalls modifiziert. Wir zeigen die neuen Vorgaben im Kapitel *Farbsysteme* ab der Seite 11.

3.4 ProzessStandard Offset- und ProzessStandard Digitaldruck

3.4.1 ProzessStandard Offsetdruck – PSO

Der ProzessStandard Offsetdruck, PSO, wurde von der FOGRA, Forschungsinstitut für Medientechnologie e.V., und dem bvdm, Bundesverband Druck und Medien e.V., zur Standardisierung des Offsetdruckverfahrens entwickelt. Basis des PSO ist die Norm ISO 12647-2. Der neue ProzessStandard Offsetdruck 2012 wurde vollkommen überarbeitet und vereinigt künftig alle Offsetdruckverfahren incl. Zeitungs- und Schmalbahn-Rollenoffsetdruck. 2016 erfolgte eine Revision zur Aktualisierung.

Der bvdm hat die wichtigsten Inhalte des PSO in der Veröffentlichung „MedienStandard Druck 2016 – Technische Richtlinien für Daten, Prüfdruck und Auflagendruck" veröffentlicht. Sie können den Medienstandard 2016 kostenlos unter www.bvdm-online.de als PDF herunterladen.

Medienstandard Druck 2016
www.bvdm-online.de

ProzessStandard Digitaldruck – PSD
www.fogra.org

3.4.2 ProzessStandard Digitaldruck – PSD

Der ProzessStandard Offsetdruck hat sich in der Praxis bewährt. Die verschiedenen Prozessparameter sind ebenso wie die Prozesskontrollstandards definiert und im Druckprozess umzusetzen. Im Digitaldruck ist dies wesentlich schwieriger. Die Digitaldrucksysteme arbeiten mit unterschiedlichen Bebilderungstechnologien und spezifisch darauf abgestimmten Materialien. Der ProzessStandard Digitaldruck, PSD, trennt deshalb Prozesskontrolle und Qualitätskontrolle.

- *Prozesskontrolle*
 Die Prozesskontrolle umfasst die drucksystemspezifischen Einstellungen und dazu nötigen visuellen und messtechnischen Prüfungen.

- *Qualitätssicherung*
 Die Qualitätssicherung im Sinne des PSD umfasst die Bewertung des finalen Druckergebnisses.

Mit der ISO-Norm 15311 soll zukünftig für alle Digitaldrucktechnologien vom kleinformatigen Druck bis zum großformatigen Large Format Printing ein prozessunabhängiger Produktionsprozess- und Qualitätsstandard definiert werden.

49

	PC1/PS1/CD1	PC2/PS2/CD2	PC3/PS3/CD3	PC4/PS4/CD4																																																																										
Druckverfahren	Bogenoffset Rollenoffset (Heatset)	Bogenoffset Rollenoffset (Heatset)	Rollenoffset (Heatset)	Rollenoffset (Heatset)																																																																										
Papier	Premium coated Bilderdruck (alt PT1 + 2)	Improved coated Bilderdruck	Standard glossy coated Magazinpapier, LWC	Standard matte coated Magazinpapier, LWC																																																																										
Flächenmasse [g/m²]	80 – 250 (115)	51 – 80 (70)	48 – 70 (51)	51 – 65 (54)																																																																										
Weißgrad	105 – 135	90 – 105	60 – 90	55 – 90																																																																										
Glanz	10 – 80	25 – 60	60 – 80	7 – 35																																																																										
Rasterung	AM [cm⁻¹] FM [µm]	AM [cm⁻¹] FM [µm]	AM [cm⁻¹] FM [µm]	AM [cm⁻¹] FM [µm]																																																																										
	60 – 80 20 (25)	48 – 70 25	48 – 60 30	48 – 60 30																																																																										
Tonwertzu-nahmekurve	A E	B E	B E B (CMY) und C (K)	B E B (CMY) und C (K)																																																																										
Farbaufbau	GCR	GCR	GCR	GCR																																																																										
Schwarzlänge	9	9	10	10																																																																										
Schwarzbreite	10	10	10	10																																																																										
max. Deckung [%]	300	300	300	300																																																																										
max. Schwarz [%]	96	96	98	98																																																																										
CMS	Heidelberg ColorTool	Heidelberg ColorTool	Heidelberg ColorTool	Heidelberg ColorTool																																																																										
Profil	PSOcoated_v3.icc FOGRA51	PSOuncoated_v3_ FOGRA52.icc	PSO_LWC_Standard_ eci.icc FOGRA46	PSO_LWC_Standard_ eci.icc FOGRA46																																																																										
L*	a*	b* weiße Mess-unterlage (wb) Messung M1	16	0	0 56	-36	-51 48	75	-4 89	-4	93 48	68	47 50	-65	26 25	20	-46 23	0	-1 95	1	-4	20	1	2 58	-37	-46 48	73	-6 87	-4	90 48	66	45 51	-59	27 28	16	-46 28	-4	-1 93	0	-1	20	1	2 55	-36	-43 46	70	-3 84	-2	89 47	64	45 49	-56	28 27	15	-42 27	-3	0 90	0	1	24	1	2 56	-33	-42 48	68	-1 85	-2	83 47	63	41 50	-53	26 28	16	-38 27	0	-2 91	0	1

Charakterisierungsdaten Offset für die Druck-
bedingungen nach ISO 12647-2:2013

	PC5/PS5/CD5		PC6/PS6/CD6		PC7/PS7/CD7		PC8/PS8/CD8	
Druckverfahren	Rollenoffset (Heatset)		Rollenoffset (Heatset)		Rollenoffset (Heatset)		Rollenoffset (Heatset)	
Papier	Wood-free coated Naturpapier (alt PT4)		Super calandered uncoated SC-Papier		Improved uncoated Zeitungspapier		Standard uncoated Zeitungspapier	
Flächenmasse [g/m²]	70 – 250 (120)		38 – 60 (56)		40 – 56 (49)		40 – 52 (45)	
Weißgrad	140 – 175		45 – 85		40 – 80		35 – 60	
Glanz	5 – 15		30 – 55		10 – 35		5 – 10	
Rasterung	AM [cm⁻¹]	FM [µm]	AM [cm⁻¹]	FM [µm]	AM [cm⁻¹]	FM [µm]	AM [cm⁻¹]	FM [µm]
	52 – 70	30 (35)	48 – 60	35	48 – 60	35	48 – 60	35
Tonwertzu-nahmekurve	C	E	B	E	C	E	C	E
						C (CMY) und D (K)		C (CMY) und D (K)
Farbaufbau	GCR		GCR		GCR		GCR	
Schwarzlänge	9		9		10		9	
Schwarzbreite	10		10		10		10	
max. Deckung [%]	300		270		260		260	
max. Schwarz [%]	96		96		98		98	
CMS	Heidelberg ColorTool		Heidelberg ColorTool		Heidelberg ColorTool		Heidelberg ColorTool	
Profil	PSOuncoated_v3_FOGRA52.icc		PSOsc-b_paper_v3_FOGRA54.icc		PSO_INP_Paper_eci.icc FOGRA 48		PSO_SNP_Paper_eci.icc FOGRA 42	

L*|a*|b*

weiße Mess-unterlage (wb)
Messung M1

PC5/PS5/CD5	PC6/PS6/CD6	PC7/PS7/CD7	PC8/PS8/CD8								
33	1	1	23	1	2	32	1	3	30	1	2
60	-25	-44	56	-36	-40	59	-29	-35	54	-26	-31
55	60	-2	48	67	-4	53	59	-1	51	55	1
89	-3	76	84	0	86	83	-1	73	79	0	70
53	56	27	47	63	40	51	57	31	48	53	31
53	-43	14	49	-53	25	53	-43	18	47	-38	20
39	9	-30	28	13	-41	37	8	-31	36	9	-25
35	0	-3	27	-1	-3	34	-3	-5	33	-1	0
95	1	-4	90	0	3	89	0	3	85	1	5

Charakterisierungsdaten Offset für die Druck-bedingungen nach ISO 12647-2:2013

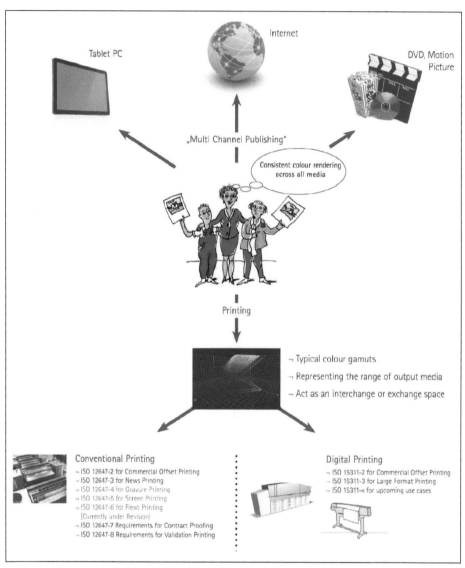

„Farberwartungen erfüllen" (engl. Printing the Expected)

Schematische Darstellung der vielfältigen Ausgabeverfahren sowie der für die Druckindustrie zentralen Bedeutung von Austauschfarbräumen samt Trennung in Prozessleitfäden für den konventionellen und den Digitaldruck

3.5 RGB-Profile

3.5.1 Kameraprofile

Jede Digitalkamera hat eine eigene
Farbcharakteristik, die sich in der Auf-
nahme bzw. Wiedergabe von Farben
zeigt. Die Sensoren in Digitalkameras,
Smartphones und Tablets erfassen,
wie die Netzhaut des menschlichen
Auges, das aufgenommene Licht in den
Teilfarben Rot. Grün und Blau. Die vom
Sensor erfassten Farben bilden den
RGB-Kamerafarbraum.

In der Praxis finden meist folgende
zwei RGB-Farbräume definiert durch
die Farbprofile Anwendung:

- *sRGB*
 Der sRGB-Farbraum ist kleiner als der
 Farbraum moderner Druckmaschi-
 nen, Farbdrucker oder Monitore, er ist
 deshalb nur bedingt für den Print-
 workflow geeignet.
- *Adobe RGB*
 Dieser Farbraum hat einen großen
 Farbumfang. Adobe RGB ist neben
 dem sRGB-Farbraum in vielen Digital-
 kameras als Kameraarbeitsfarbraum
 installiert. Sie können vor der Aufnah-
 me zwischen sRGB und Adobe RGB
 auswählen.

3.5.2 Monitorprofile

Der Monitor ist im Workflow die
visuelle Schnittstelle zwischen dem
Mediengestalter und den Farben des
Dokuments. Für die professionelle
Medienproduktion ist eine konsistente
Farbdarstellung in allen Produktions-
schritten wichtig. Dies wird durch das
Monitorfarbprofil erreicht. Monitorpro-
file beschreiben den Farbraum eines
Monitors.

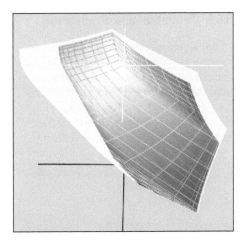

**Vergleich Farbraum-
umfang sRGB –
Adobe RGB (CIELAB-
System)**

Der deutlich größere
Adobe RGB-Farbraum
ist weiß dargestellt.

Kameramenü

Auswahl der vorin-
stallierten Farbprofile

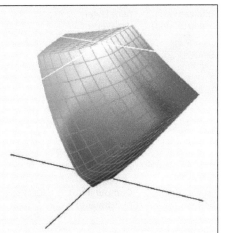

Mein_Monitorprofil

Messtechnisch mit
Eye-One erstelltes
ICC-Monitorprofil

3.6 Eingabeprofilierung

3.6.1 Digitalkamera-Profilierung

In der Kamerasoftware ist das Kameraprofil bereits ab Werk installiert. Darüber hinaus können Sie mit spezieller Soft- und Hardware auch eigene Kameraprofile erstellen und diese in die Kamerasoftware einbinden. Das vorinstallierte Farbprofil wird damit

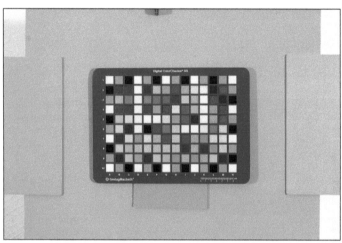

Testchart Digitalkamera-Profilierung

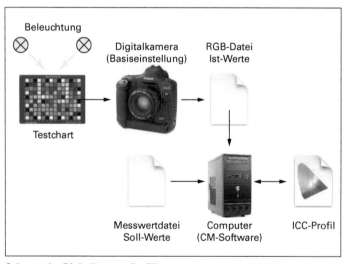

Schema der Digitalkamera-Profilierung

durch das kameraspezifische Farbprofil ersetzt.

Profilerstellung
Zur Erstellung von ICC-Profilen Ihrer Digitalkamera benötigen Sie neben der CM-Software ein spezielles Testchart. Die Testfelder des Charts verteilen sich mit verschiedenen Farben und unterschiedlichen Helligkeits- bzw. Sättigungswerten über das ganze Chartformat. Um Reflexionen zu vermeiden und trotzdem eine möglichst optimale Farberfassung zu erreichen, sollte die Oberfläche halbmatt sein. Im CM-System der Firma XRite sind Testcharts, sogenannte Color Checker, im Lieferumfang enthalten. Die IT8-Charts zur Scannerprofilierung sind für die Kameraprofilierung ungeeignet.

Die Beleuchtung spielt naturgemäß bei der fotografischen Aufnahme eine entscheidende Rolle. Durch die Profilierung in verschiedenen Beleuchtungssituationen können Sie Profile für verschiedene Lichtarten und Einsatzzwecke erstellen. Selbstverständlich ist ein korrekter Weißabgleich die Grundvoraussetzung für die Erstellung eines guten Kameraprofils. Die übrigen Kameraeinstellungen wie z. B. Schärfefilter sollten bei der Aufnahme zur Profilierung die Basiseinstellung haben.

Profileinbindung
Nach der Profilerstellung müssen Sie im Dienstprogramm Ihrer Kamera das Kameraprofil als Quellprofil und das Zielprofil als Arbeitsfarbraum, in dem Ihr Bild gespeichert wird, definieren.

3.6.2 Scannerprofilierung

Für die Profilierung Ihres Scanners
stehen von verschiedenen Herstellern
Softwaretools zur Verfügung. Die Vor-
gehensweise ist grundsätzlich bei allen
Tools die gleiche.

Test-Target scannen
Mit Ihrer Profilierungssoftware erhalten
Sie verschiedene Testvorlagen, z. B. die
IT8-Vorlage. Sie müssen für Aufsicht
und Durchsicht jeweils eigene Profile
erstellen. Ebenso unterscheidet sich die
Farbcharakteristik der Aufnahmemateri-
alien der verschiedenen Hersteller, z. B.
Agfa oder Fuji.

Welche Scanparameter Sie einstellen
müssen, wird von der Profilierungssoft-
ware vorgegeben. Grundsätzlich gilt,
wie bei der Profilierung einer Digital-
kamera, stellen Sie in der Scansoftware
alle Einstellungsgrößen am Scanner
bzw. in der Scansoftware auf die Basis-
einstellung.

ICC-Scannerprofil berechnen
Die Profilierungssoftware vergleicht
jetzt die gescannten Farbwerte der
Testvorlage mit den gespeicherten
Referenzfarbdaten. Aus dem Vergleich
ergibt sich die individuelle Farbcharak-
teristik Ihres Scanners bezogen auf die
jeweilige Testvorlage. Als Ergebnis der
Berechnung erhalten Sie ein ICC-Profil
für Ihren Scanner.

ICC-Profil speichern
Damit Sie das Scannerprofil auch nut-
zen können, müssen Sie es speichern.
- *Mac OS*
 Festplatte > Users > Username >
 Library > ColorSync > Profiles
- *Windows*
 Festplatte > windows > system32 >
 spool > drivers > color1.2.4.3

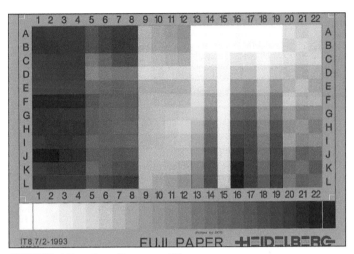

IT8.7/2-Test-Target zur Scannerprofilierung

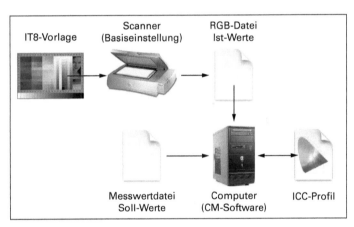

Schema der Scannerprofilierung

ICC-Profilauswahl in der Scannersoftware

3.6.3 Eingabe-Profilvergleich

Die dreidimensionale Darstellung der ICC-Profile im LAB-Farbraum zeigt den unterschiedlichen Farbraumumfang der verschiedenen Eingabefarbräume.

Sie können auf dem Apple Macintosh mit ColorSync selbst die Farbraumdarstellungen der von Ihnen verwendeten Farbräume ansehen und vergleichen. ColorSync finden Sie unter *Applications > Utilities > ColorSync.*

Nikon sRGB-Farbraum
Häufig verwendeter Standard-RGB-Farbraum in der Digitalfotografie mit Digitalkameras der Firma Nikon

Epson RGB-Scanner-Farbraum
Farbraum des Epson Scanners 1670

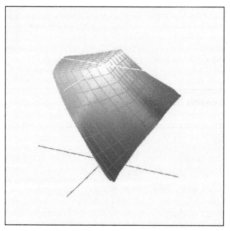

Kodak Generic DCS Camera Input
Allgemeiner RGB-Farbraum in der Digitalfotografie mit Digitalkameras der Firma Kodak

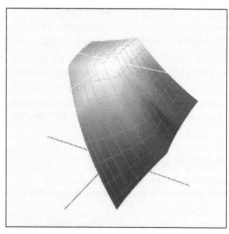

Epson sRGB-Farbraum

3.7 Monitorprofilierung

Der Monitor ist im Workflow die visuelle Schnittstelle zwischen dem Mediengestalter und den Farben des Bildes bzw. der Grafik. Sie haben in allen Bildverarbeitungsprogrammen die Möglichkeit, Farben numerisch zu kontrollieren und bei Bedarf auch durch numerische Eingabe im Dialog zu modifizieren. Trotzdem ist die visuelle Beurteilung der Monitordarstellung immer noch das Wichtigste bei der Farbverarbeitung. Deshalb ist es unabdingbar, dass Sie nicht nur die Eingabe bzw. Erfassung der Bilddaten mit einer Digitalkamera oder im Scanner und die Ausgabe im Digitalproof und Fortdruck profilieren, sondern auch die Ausgabe und Darstellung der Farben auf dem Monitor. Obwohl die Internet-Browser derzeit (2017) Farbprofile noch meist ignorieren, ist es auch zur professionellen Bildverarbeitung für Digitalmedien notwendig, eine verlässliche Anzeige auf dem Monitor zu haben.

Ein konsistenter Farbworkflow in der Medienproduktion erfordert deshalb die Definition der Monitordarstellung. Dies können Sie durch die Kalibrierung und die Profilierung Ihres Monitors durch ICC-Profile erreichen. Sie können ein Profil messtechnisch oder visuell mit verschiedenen Dienstprogrammen wie z. B. Windows Bildschirm-Farbkalibrierung oder dem Apple Monitorkalibrierungs-Assistenten erstellen und im System Ihres Computers abspeichern.

3.7.1 Grundregeln der Profilierung

Die messtechnische oder visuelle Profilierung eines Monitors erfolgt immer nach den gleichen Regeln:
- Der Monitor soll wenigstens eine halbe Stunde in Betrieb sein.
- Kontrast und Helligkeit müssen auf die Basiswerte eingestellt sein.

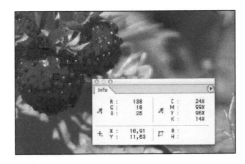

- Die Monitorwerte dürfen nach der Messung und anschließender Profilierung nicht mehr verändert werden.
- Bildschirmschoner und Energiesparmodus müssen zur Profilierung deaktiviert sein.

3.7.2 Messtechnische Profilierung

Zur Profilierung Ihres Monitors werden von verschiedenen Herstellern Mess- und Profilierungssysteme angeboten, z. B. der *i1Profiler* der Firma X-Rite. Neben der Monitorprofilierung gibt es im *i1Profiler* auch Module zur Profilierung von Scannern, Datenprojektoren (Beamern) und Druckern.

Farbwerte in der Info-Palette

Die Info-Palette zeigt die RGB- und die CMYK-Werte der ausgewählten Bildstelle (schwarzes Quadrat) bezogen auf die eingestellten RGB- bzw. CMYK-Arbeitsfarbräume.

Die RGB- und CMYK-Werte sind unabhängig vom gewählten Monitorprofil.

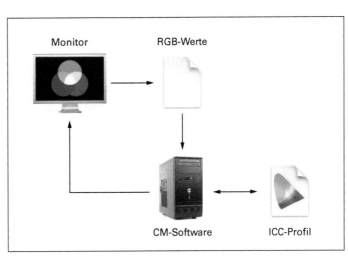

Schema der Monitorprofilierung

Startbildschirm

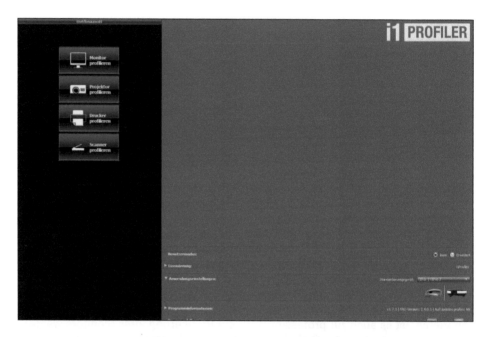

**Monitorauswahl und
Monitoreinstellungen**

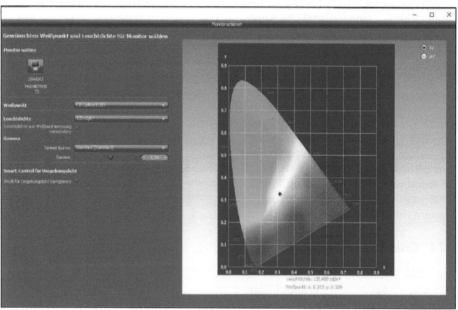

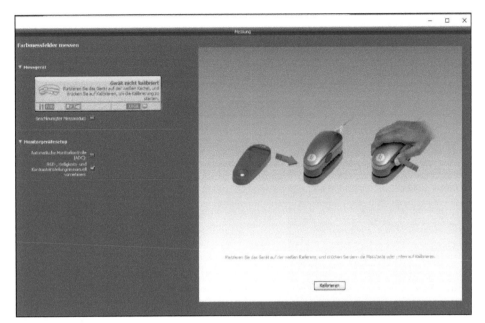

**Messgerät auf Basis-
platte kalibrieren**

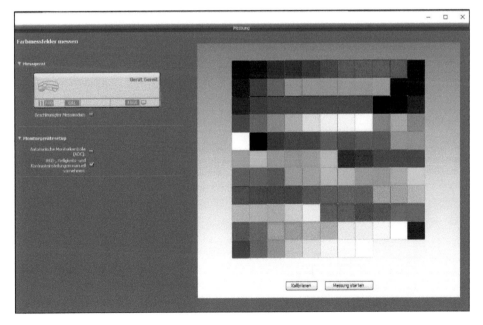

**Farbmessung durch-
führen**

Farbprofil berechnen

Farbprofil beurteilen
im CIE-Normvalenz-
system

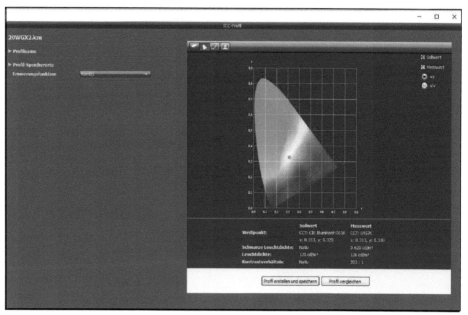

Farbprofil beurteilen

Farbbalance und
Gradation

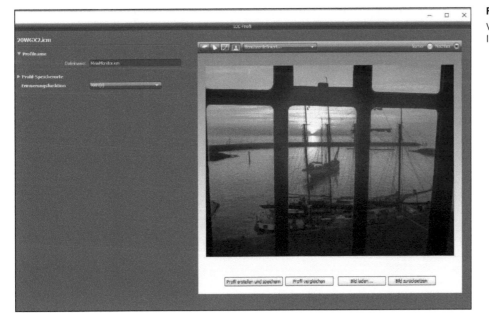

Farbprofil beurteilen

Visuelle Bilddarstel-
lung

61

3.7.3 Visuelle Profilierung

Zur visuellen Kalibrierung nutzen Sie die Systemtools von macOS oder Windows. Natürlich müssen sie auch bei der visuellen Kalibrierung die Grundregeln beachten:

- Der Monitor soll wenigstens eine halbe Stunde in Betrieb sein.
- Kontrast und Helligkeit müssen auf die Basiswerte eingestellt sein.
- Die Monitorwerte dürfen nach der Kalibrierung nicht mehr verändert werden.
- Bildschirmschoner und Energiesparmodus müssen zur Profilierung deaktiviert sein.

Apple Monitorkalibrierungs-Assistent

Auf dem Apple Macintosh können Sie mit dem Monitorkalibrierungs-Assistenten ein Monitorprofil erstellen: Menü *Apple > Systemeinstellungen... > Monitore > Farben > Kalibrieren.*

Windows Kalibrierungs-Assistent

Mit dem Kalibrierungs-Assistenten können Sie Ihren Monitor unter Windows visuell kalibrieren. Er ist Teil des Betriebssystems. Starten Sie den Kalibrierungs-Assistenten über *Systemsteuerung > Darstellung und Anpassung > Anzeige > Bildschirmfarbe kalibrieren* oder durch Aufrufen des Programms dccw.exe. Folgen Sie im Weiteren den Dialogen des Assistenten.

Schritt 1: Gamma anpassen

Bewegen Sie den Schieberegler, bis die Punkte im Testbild nicht mehr sichtbar sind.

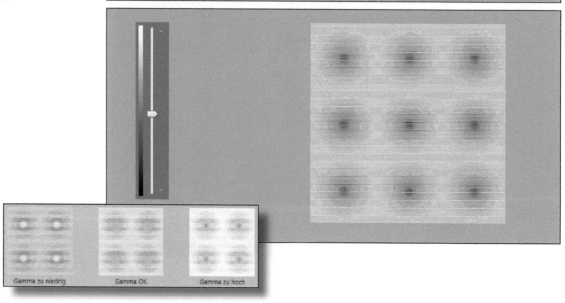

Mit dem Gammawert werden die mathematische Beziehung zwischen den an den Bildschirm gesendeten Rot-, Grün- und Blauwerten sowie die von diesem ausgestrahlte Menge Licht definiert.

Zum Anpassen des Gammawerts auf der nächsten Seite versuchen Sie, das Bild so einzustellen, dass dieses wie das Beispielbild mit der Beschriftung "Gamma OK" aussieht.

Gamma zu niedrig Gamma OK Gamma zu hoch

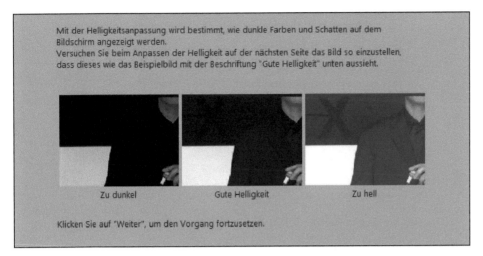

Mit der Helligkeitsanpassung wird bestimmt, wie dunkle Farben und Schatten auf dem Bildschirm angezeigt werden.
Versuchen Sie beim Anpassen der Helligkeit auf der nächsten Seite das Bild so einzustellen, dass dieses wie das Beispielbild mit der Beschriftung "Gute Helligkeit" unten aussieht.

| Zu dunkel | Gute Helligkeit | Zu hell |

Klicken Sie auf "Weiter", um den Vorgang fortzusetzen.

Schritt 2: Helligkeit anpassen

Stellen Sie die Helligkeit der Monitordarstellung mit dem Helligkeitsregler Ihres Monitors ein. Je nach Bauart des Monitors ist dies eine Taste am Monitor oder ein Anzeigeeinstellregler im Bildschirmmenü.

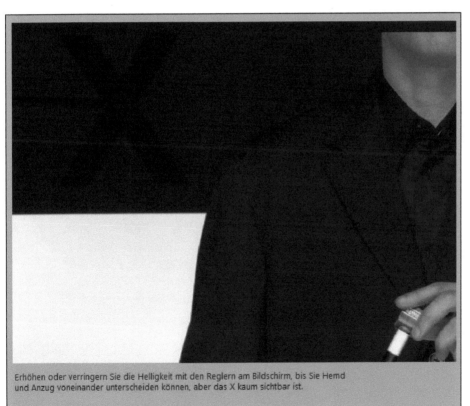

Erhöhen oder verringern Sie die Helligkeit mit den Reglern am Bildschirm, bis Sie Hemd und Anzug voneinander unterscheiden können, aber das X kaum sichtbar ist.

63

Schritt 3: Kontrast anpassen

Stellen Sie den Kontrast der Monitordarstellung mit dem Kontrastregler Ihres Monitors ein. Je nach Bauart des Monitors ist dies eine Taste am Monitor oder ein Anzeigeeinstellregler im Bildschirmmenü.

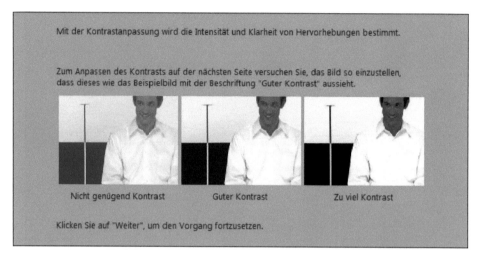

Mit der Kontrastanpassung wird die Intensität und Klarheit von Hervorhebungen bestimmt.

Zum Anpassen des Kontrasts auf der nächsten Seite versuchen Sie, das Bild so einzustellen, dass dieses wie das Beispielbild mit der Beschriftung "Guter Kontrast" aussieht.

Nicht genügend Kontrast Guter Kontrast Zu viel Kontrast

Klicken Sie auf "Weiter", um den Vorgang fortzusetzen.

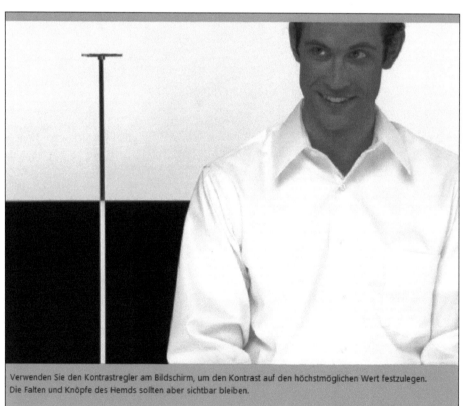

Verwenden Sie den Kontrastregler am Bildschirm, um den Kontrast auf den höchstmöglichen Wert festzulegen. Die Falten und Knöpfe des Hemds sollten aber sichtbar bleiben.

Schritt 4: Farbbalance anpassen

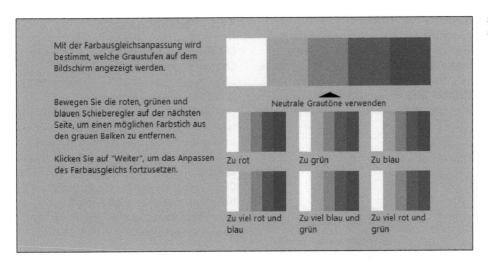

Mit der Farbausgleichsanpassung wird bestimmt, welche Graustufen auf dem Bildschirm angezeigt werden.

Bewegen Sie die roten, grünen und blauen Schieberegler auf der nächsten Seite, um einen möglichen Farbstich aus den grauen Balken zu entfernen.

Klicken Sie auf "Weiter", um das Anpassen des Farbausgleichs fortzusetzen.

Neutrale Grautöne verwenden

Zu rot

Zu grün

Zu blau

Zu viel rot und blau

Zu viel blau und grün

Zu viel rot und grün

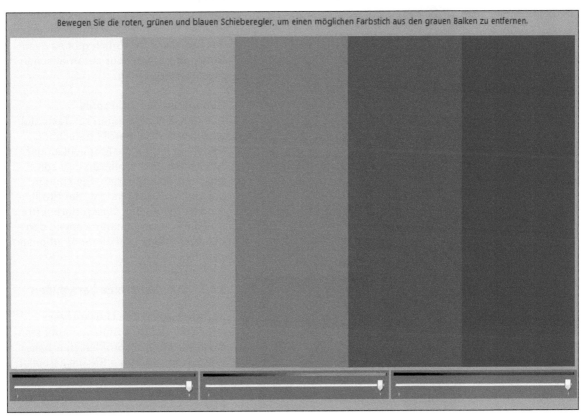

Bewegen Sie die roten, grünen und blauen Schieberegler, um einen möglichen Farbstich aus den grauen Balken zu entfernen.

3.8 Ausgabeprofilierung

Systeme zur Profilierung der Druck-
ausgabe werden von verschiedenen
Herstellern angeboten. Alle Systeme
enthalten Dateien zur Erzeugung eines
Testdrucks, Ist-Werte als Referenz-
dateien und ein spektralfotometrisches
Messgerät zur Messung der Testdrucke.

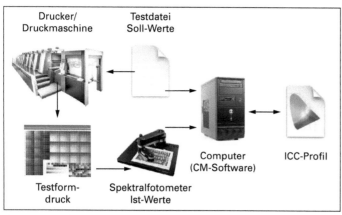

Schema der Ausgabeprofilierung

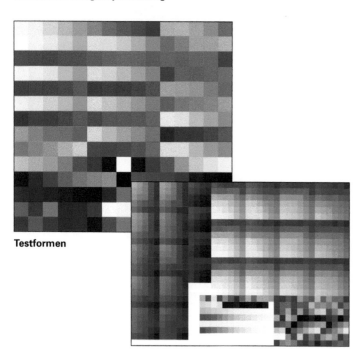

Testformen

3.8.1 Verfahrensablauf

Die Profilerstellung erfolgt in allen
Systemen in drei Phasen:

Ausdrucken der Testform
Die als Datensatz vorliegende Testvor-
lage wird als Druckdatei an den Drucker
übermittelt und ausgedruckt. Im kon-
ventionellen Druck wird die Datei unter
standardisierten Bedingungen über ein
CtP-System direkt auf die Druckform
belichtet. Der anschließende Druck
muss selbstverständlich ebenfalls stan-
dardisiert erfolgen.

Farbmetrisches Ausmessen
Die einzelnen Farbfelder des Ausdrucks
werden mit einem Spektralfotometer
ausgemessen. Natürlich gibt es dazu
Spektralfotometer zur automatischen
Messwerterfassung.

Generieren des ICC-Profils
Aus den Abweichungen zur Testdatei
wird das Ausgabeprofil berechnet.
Dabei haben Sie die Möglichkeit der
Anpassung des Profils an Ihre spe-
zifischen Bedingungen. Sie können
bei der Profilerstellung in der Profilie-
rungssoftware den Gesamtfarbauftrag
und die Tonwertzunahme sowie den
Schwarzaufbau und die Separationsart
definieren.

3.8.2 Standardprofile verwenden

Im standardisierten Druckprozess
macht es natürlich Sinn auch mit stan-
dardisierten Druckprofilen zu arbeiten.
Wie bekannt, können Sie die aktuellen
Profile z. B. von www.eci.org kostenlos
herunterladen und auf dem Arbeits-
platzrechner installieren.

3.9 Gamut-Mapping

Unter Gamut-Mapping versteht man die Transformation der Farbräume zwischen einzelnen Stationen des Workflows.

3.9.1 PCS – Profile Connection Space

Die Kommunikation über Farbe muss in einem gemeinsamen Sprach- bzw. Farbraum erfolgen. Dieser Farbraum soll alle am Workflow beteiligten Farbräume umfassen und eine eindeutige Übersetzung zwischen den Farbräumen ermöglichen. Die XYZ-, Yxy- und LAB-Farbräume erfüllen diese Forderungen. Sie umfassen alle für den Menschen sichtbaren Farben und somit automatisch alle Prozessfarbräume. Die Farborte sind eindeutig und prozessunabhängig definiert und können somit in die jeweiligen Prozessfarbanteile, d. h. RGB bzw. CMYK, umgerechnet werden.

In den Spezifikationen der ICC-Profile und des Gamut-Mappings wurden vom ICC, International Color Consortium, und der ECI, European Color Initiative, der XYZ- und der LAB-Farbraum als allgemein gültige Referenzfarbräume festgelegt.

Da das Gamut-Mapping zwischen den Profilen in diesem Farbraum stattfindet, wird dieser auch als Profile Connection Space, PCS, bezeichnet.

Das ICC-Profil stellt die Beziehung des individuellen Gerätefarbraums zum geräteunabhängigen PCS her.

Das im Betriebssystem des jeweiligen Computers integrierte CMM, Color Matching Modul, steuert die profilgestützte Farbverarbeitung. Durch die Wahl von Rendering Intents legen Sie den jeweiligen Algorithmus fest.

3.9.2 CMM – Color Matching Modul

Das Color Matching Modul ist als Teil des Betriebssystems die Software auf Ihrem Computer, mit der das Gamut-Mapping durchgeführt wird. Mit der Installation der CM-Software wird meist ein eigenes CMM installiert. Da aber verschiedene CMMs mit den gleichen ICC-Profilen zu unterschiedlichen Ergebnissen führen, empfiehlt es sich, immer das gleiche CMM, z. B. Adobe (ACE), zu verwenden.

3.9.3 Rendering Intent

Das Rendering Intent ist der Umrechnungsalgorithmus der Farbraumtransformation. Welches Rendering Intent Sie auswählen, ist von der jeweiligen Anwendung abhängig.

Wir unterscheiden vier verschiedene Optionen:
- Perzeptiv bzw. perceptual, fotografisch, wahrnehmungsorientiert
- Sättigung bzw. saturation
- Relativ farbmetrisch bzw. relative colorimetric
- Absolut farbmetrisch bzw. absolute colorimetric

Perzeptiv
Perzeptiv ist die übliche Einstellung bei allen Farbraumtransformationen von Farbbildern, außer bei der Prooferstel-

lung. Bei der Prooferstellung erfolgt das Gamut-Mapping *farbmetrisch*.

Die Einstellung *perzeptiv* bewirkt beim Gamut-Mapping eine nichtlineare Anpassung des Quellfarbsystems an das Zielfarbsystem. Der visuelle Charakter des Bildes soll dadurch bei der Farbraumtransformation möglichst bewahrt werden. Bei der Transformation werden Farben, die weit außerhalb des Zielfarbraums liegen, sehr stark verschoben, Farben am Rand des Zielraums weniger stark und Farben, die im Inneren des Zielfarbraums liegen, nur ganz leicht. Die Option der Wahl bei stark unterschiedlichen Farbräumen.

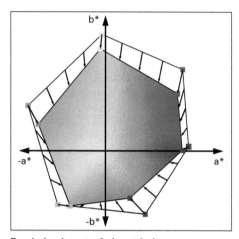

Rendering Intent – farbmetrisch

Rendering Intent – perzeptiv

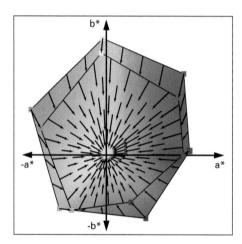

Farbmetrisch

Die Einstellung *farbmetrisch* bewirkt das Stanzen eines kleineren Farbraums in einen größeren Farbraum. Dadurch wird der kleine Farbraum exakt im größeren Farbraum abgebildet. Deshalb ist *farbmetrisch* das Rendering Intent beim Proofen und der Umwandlung von ähnlich großen Farbräumen.

Absolut farbmetrisch

Die Option *absolut farbmetrisch* passt den Weißpunkt des Zielfarbraums (Proof) an den Weißpunkt des Quellfarbraums (Druck) an. Die Papierfärbung wird also im geprooften Bild simuliert. Wählen Sie diese Option, wenn das Proofpapier farblich nicht dem Auflagenpapier entspricht.

Relativ farbmetrisch

Bei der Option *relativ farbmetrisch* wird der Weißpunkt des Zielfarbraums (Proof) nicht an den Weißpunkt des Quellfarbraums (Druck) angepasst. Sie wählen deshalb diese Option, wenn das Proofpapier farblich dem Auflagenpapier entspricht.

Sättigung

Hier werden kräftige Farben auf Kosten der Farbtreue erstellt. Der Quellfarbumfang wird in den Zielfarbumfang skaliert, aber anstelle des Farbtons bleibt die relative Sättigung erhalten, so dass sich Farbtöne bei der Skalierung in einen kleineren Farbumfang verschieben können. Die Priorität für Grafiken mit leuchtenden und satten Farben.

Gamut-Mapping

einer sRGB-Bilddatei mit den Rendering Intents:
- perzeptiv
- relativ farbmetrisch
- absolut farbme-trisch

Links:
ISOcoated_v2_eci.icc
Rechts:
ISOnewspaper26v4.icc

ISOcoated_v2_eci.icc – perzeptiv

ISOnewspaper26v4.icc – perzeptiv

ISOcoated_v2_eci.icc – relativ farbmetrisch

ISOnewspaper26v4.icc – relativ farbmetrisch

ISOcoated_v2_eci.icc – absolut farbmetrisch

ISOnewspaper26v4.icc – absolut farbmetrisch

69

3.9.4 Gamut-Mapping mit Device-Link-Profilen

Device-Link-Profile werden vor allem eingesetzt, wenn eine schon separierte Datei in einen anderen CMYK-Farbraum konvertiert werden muss. In unserem Beispiel wurde die Datei im Offset auf ein glänzend gestrichenes Papier von Papiertyp 1 gedruckt. Der Nachdruck soll auf ein maschinengestrichenes Papier gedruckt werden. Um ein optimales Druckergebnis zu erzielen, erfolgt eine Profilkonvertierung von ISOcoated_v2_300_eci.icc nach PSO_MFC_Paper_eci.icc.

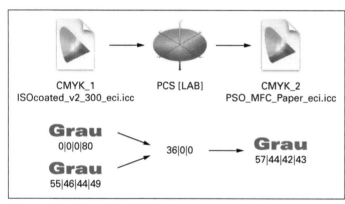

Farbraumtransformation mit PCS

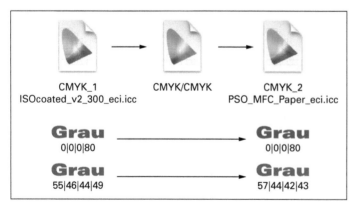

Farbraumtransformation mit Device-Link

Bei der Transformation von Farbräumen über ein Device-Link-Profil findet keine Zwischentransformation in einen prozessneutralen Profile Connection Space, z. B. LAB, statt. Dies hat den Vorteil, dass die Separation der Datei grundsätzlich erhalten bleibt. Der Schwarzkanal bleibt erhalten und somit auch die reinschwarze Information in Grafiken oder Texten.

RGB-zu-CMYK-Separation
Auf die Druckbedingungen hin optimierte Separation unter Beibehaltung der Graubalance.

CMYK-Reseparation
Verschiedene Dateien mit unterschiedlicher Separation und Farbprofilen werden durch die Reseparation in einen einheitlichen Farbaufbau transformiert.
Zusätzlich kann durch ein starkes GCR der Druckfarbverbrauch optimiert werden.

CMYK-zu-CMYK-Konvertierung
Der Farbaufbau bleibt grundsätzlich erhalten, die Konvertierung dient nur der Anpassung an die spezifischen Druckbedingungen wie z. B. die veränderte Tonwertzunahme.

eciCMYK (FOGRA53)
Das eciCMYK-Profil der ECI ist ein CMYK-Austauschprofil mit dem CMYK-Austauschfarbraum FOGRA53 für die medienneutrale Printproduktion im CMYK-Modus. Da der Austauschfarbraum naturgemäß größer ist als der jeweilige Druckfarbraum, kann mit dem eciCMYK-Profil nicht direkt gedruckt werden. Damit bei einer Konvertierung die Separation mit dem Schwarzaufbau nicht verloren geht, muss mit einem Device-Link konvertiert werden. Kostenloser Download unter www.eci.org.

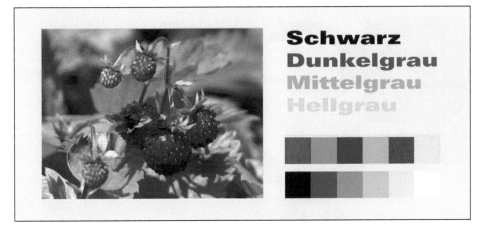

Schwarz
Dunkelgrau
Mittelgrau
Hellgrau

Referenzdatei

ISOcoated_v2_300_
eci.icc

Grauskala (%):
C 0|0|0|0|0|0
M 0|0|0|0|0|0
Y 0|0|0|0|0|0
K 100|80|60|40|20|0

Schwarz
Dunkelgrau
Mittelgrau
Hellgrau

Gamut-Mapping mit PCS

ISOcoated_v2_300_
eci.icc
nach
ISOwebcoated.icc

Grauskala (%):
C 82|64|50|32|13|1
M 74|54|40|24|9|1
Y 56|47|35|20|5|0
K 86|27|3|0|0|0

Neue Separation, Verlust der reinschwarzen Information

Schwarz
Dunkelgrau
Mittelgrau
Hellgrau

Gamut-Mapping mit Device-Link

ISOcoated_v2_300_
eci.icc
nach
ISOwebcoated.icc

Grauskala (%):
C 0|0|0|0|0|0
M 0|0|0|0|0|0
Y 0|0|0|0|0|0
K 100|78|56|36|17|0

Tonwertanpassung durch höhere Tonwertzunahme

71

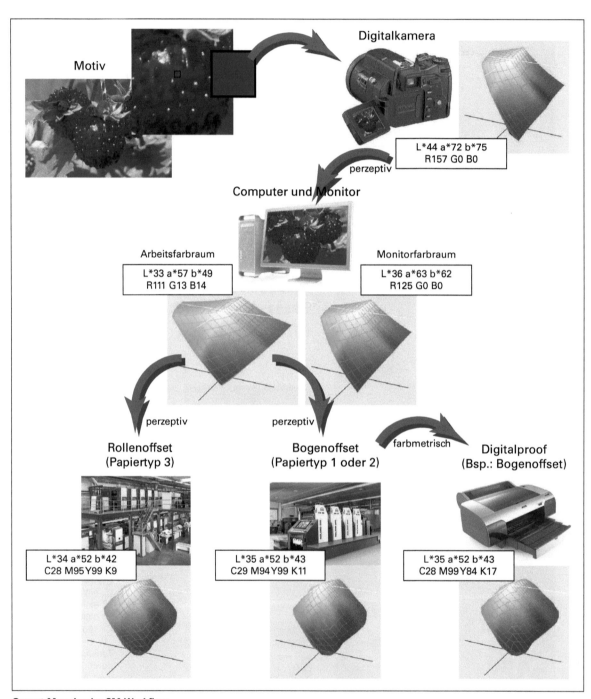

Motiv

Digitalkamera

L*44 a*72 b*75
R157 G0 B0

perzeptiv

Computer und Monitor

Arbeitsfarbraum

L*33 a*57 b*49
R111 G13 B14

Monitorfarbraum

L*36 a*63 b*62
R125 G0 B0

perzeptiv

perzeptiv

farbmetrisch

Rollenoffset
(Papiertyp 3)

Bogenoffset
(Papiertyp 1 oder 2)

Digitalproof
(Bsp.: Bogenoffset)

L*34 a*52 b*42
C28 M95 Y99 K9

L*35 a*52 b*43
C29 M94 Y99 K11

L*35 a*52 b*43
C28 M99 Y84 K17

Gamut-Mapping im CM-Workflow

3.10 Prozesskontrolle

3.10.1 ECI-Monitortest

Die ECI hat einen Monitortest entwickelt, der es Ihnen erlaubt, die Kalibrierung Ihres Monitors während der Arbeit ständig visuell zu kontrollieren. Der Monitortest besteht aus einem Paket verschiedener Hintergrundbilder für PC und Mac sowie für unterschiedliche Monitorgrößen. Tauschen Sie also das geliebte Urlaubsbild gegen einen professionellen Schreibtischhintergrund aus.

Das Hintergrundbild hat als Fläche den mittleren Grauwert von R=G=B=127. Da das menschliche Auge für Farbschwankungen im neutralen Graubereich besonders empfindlich ist, können Sie Farbabweichungen über die Fläche oder in Bereichen sehr leicht wahrnehmen. Bei sogenannten Farbwolken hilft bei Röhrenmonitoren oft entmagnetisieren. Flachbildschirme bieten diese Möglichkeit natürlich nicht, hier hilft meist nur die Ersatzbeschaffung.

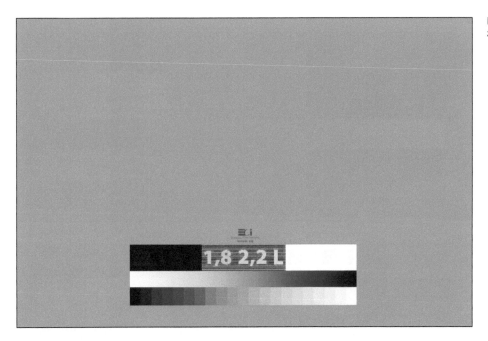

Hintergrundbild zur Monitorkontrolle

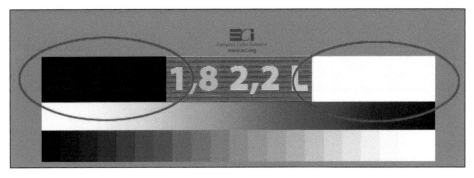

Licht- und Tiefenkontrollelement

- Helligkeit
 Das ECI-Logo darf im schwarzen Feld gerade noch sichtbar sein.
- Kontrast
 Das ECI-Logo darf im weißen Feld gerade noch sichtbar sein.

Gradationkontroll-element

Bei korrekter Gamma-einstellung ist der eingestellte Gamma-wert beim Betrachten des Testbildes mit zusammengeknif-fenen Augen nicht mehr sichtbar.

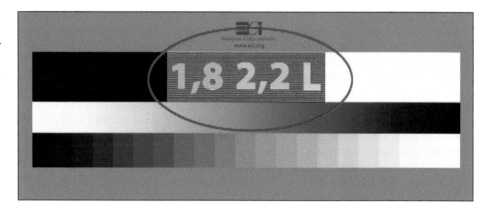

Verlaufsgraukeil

Bei korrekter Hellig-keitsdarstellung darf es zu keinen Tonwert-abrissen kommen.

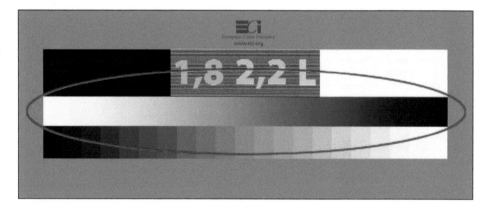

Stufengraukeil

Zur Überprüfung der Tonwertabstufung und evtl. Farbstiche in bestimmten Tonwert-bereichen

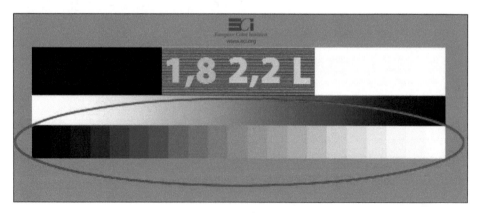

3.10.2 Fogra Monitor-Testbilder

Die Monitor-Testbilder sind Teil des Fogra-Forschungsprojektes „Aufbau und Untersuchung eines Softproof-Arbeitsplatzes". Sie stehen auf der Fogra-Forschungswebsite kostenlos zur Verfügung. Die 15 verschiedenen Testmotive eignen sich zur visuellen Beurteilung von:

- Blickwinkelcharakteristik
- Homogenität
- Pixelfehler
- Artefakt „Black Mura", Mura kommt aus dem Japanischen und bedeutet „Fehler. „Black Mura" sind schwarze Bildbereiche am Rande des Monitors, die durch Verspannungen beim Einbau des LCD-Panels auftreten.
- „Geisterbilder", Bildschatten des vorherigen Motivs, die nach dem Umschalten auf einen neuen Bildschirminhalt noch einige Zeit sichtbar sind.

Betrachtungsbedingungen

Bei der visuellen Beurteilung eines Monitors müssen Sie natürlich möglichst die Umgebungsfaktoren wie Beleuchtung, Betrachtungsabstand und Betrachtungswinkel beachten.

Oft stehen bei Abmusterungen mehrere Personen vor dem Monitor. Dadurch hat jeder einen anderen Betrachtungswinkel. Dies führt bei qualitativ nicht optimalen Monitoren zu sehr starken visuellen Veränderungen des Monitorbildes. Um diese Veränderungen rasch erkennen zu können, verlassen Sie Ihre Grundhaltung und bewegen sich in horizontaler und vertikaler Richtung vor dem Bildschirm. Simulieren Sie die in Ihrem Betrieb praxistypischen Betrachtungsbedingungen bei der Abstimmung eines Bildes oder des Softproofs am Monitor

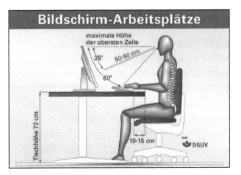

Ergonomisch richtige Grundhaltung

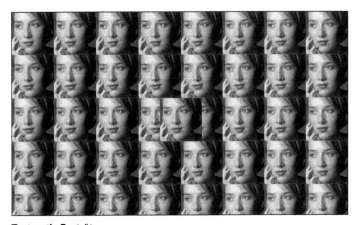

Testmotiv Porträt
Überprüfung der Blickwinkelcharakteristik und der Homogenität

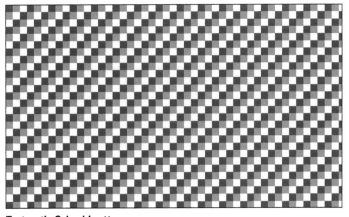

Testmotiv Schachbrett
Überprüfung des Auftretens von Geisterbildern

75

3.10.3 Softproof

Ein Softproof ist die „Darstellung von Farbdaten auf einem Monitor oder Projektor mit dem Zweck, die Farberscheinung der durch die Daten beschriebenen Farben, für bestimmte Beleuchtungs- und Umfeldbedingungen, zu synthetisieren". Soweit die Definition der Fogra. In der Praxis bedeutet dies, dass ein Druckprodukt oder eine fotografische Aufnahme farbrichtig und reproduzierbar auf einem Monitor dargestellt werden. Dies setzt eine regelmäßige messtechnische Kalibrierung und visuelle Überprüfung der Monitordarstellung voraus.

bekannt. Somit kann die Simulation der druckbaren Farben nur durch ein typisches Druckprofil wie FOGRA 39L (ISOcoated_v2_300_eci.icc) erfolgen. Eine weitere Möglichkeit ist, wie im Screenshot dargestellt, die Simulation des eigenen Fotodruckers.

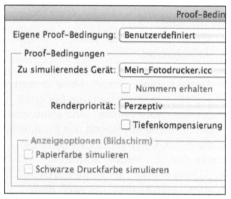

Softproof auf kalibriertem Monitor

Softproof in der Fotografie
In der Fotografie ist die konsistente, möglichst vollständige Farbdarstellung in allen eingesetzten Programmen eine Bedingung für die Darstellung der Bilddatei im Softproof. Für die Darstellung während der Bildverarbeitung in Photoshop erfolgt dies automatisch durch die relativ farbmetrische Umrechnung mit Tiefenkompensierung in das Monitorprofil. Der konkrete Ausgabeprozess ist in der Regel noch nicht

Softproof in der Reproduktion
In der Reproduktion ist häufig zusätzlich zum Softproof auf dem Monitor noch der visuelle Abgleich mit Vorlagen, Gegenständen, Drucken oder Proofs notwendig. Sie benötigen dazu außer einem kalibrierten Monitor noch eine

Abmusterkabine

Abmusterkabine mit Normlicht. Als Simulationsprofil für den Softproof wählen Sie das Farbprofil des zukünftigen Ausgabeprozesses. Für die Separation stehen zwei Rendering Intents zur Wahl: perzeptiv oder relativ farbmetrisch mit Tiefenkompensierung. Die Monitordarstellung erfolgt absolut farbmetrisch.

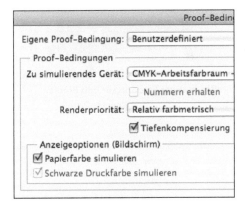

Softproof in der Druckerei
In der Druckerei ist der fertige Druckbogen Gegenstand zum Abmustern. Der Softproof dient hier anstelle des Digitalproofs als Farbreferenz für den Fortdruck.

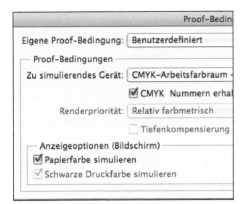

Proofstation

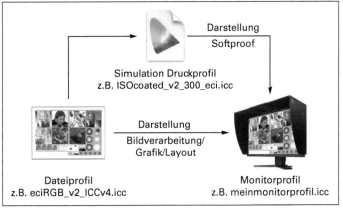

Druckfarbraumsimulation im Softproof

3.10.4 Digitalproof

Der Digitalproof oder digitale Prüfdruck hat den analogen Andruck weitgehend abgelöst. Grundbedingung ist dabei, dass der Farbraum des Proofers größer als der im Proof zu simulierende Farbraum ist und dass die Druckergebnisse reproduzierbar sind. Zur Kontrolle der Farbverbindlichkeit des Proofs muss auf jedem Ausdruck ein Ugra/Fogra-Medienkeil gemäß ISO 12647 stehen. In der Fußzeile oder auf einem speziellen Label des Proofs stehen jeweils der Dateiname, das Datum, die Bezeichnung des Prooferprofils und des geprooften Referenzdruckprofils.

Großformatiger Farbdrucker und Proofer
Epson Stylus Pro 7900 Spectro Proofer

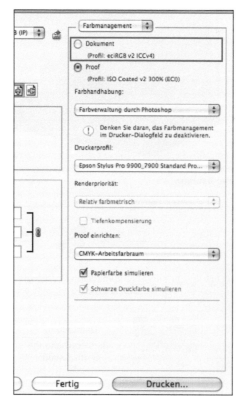

Druckereinstellungen in Photoshop
Proofen einer RGB-Datei

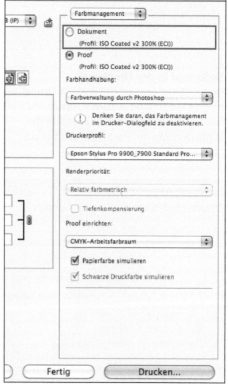

Druckereinstellungen in Photoshop
Proofen einer CMYK-Datei

3.10.5 Ugra/Fogra-Medienkeil

Die Ugra/Fogra-Medienkeile sind ein digitales Kontrollmittel, das zusammen mit der Seite ausgegeben wird. Sie können dadurch die Farbverbindlichkeit von Proof und Druck kontrollieren und nachweisen. Die Ton- bzw. Farbwerte basieren auf den Werten der internationalen Norm ISO 12642. Die Druckbedingungen sollten dem Medienstandard Offsetdruck bzw. ISO 12647-7 entsprechen.

2008 wurde die Version 3.0 des Ugra/Fogra-Medienkeils vorgestellt. Darin sind alle 46 Farbfelder der vorherigen Version enthalten. Diese wurden durch neue Farbfelder ergänzt, die eine erhöhte Empfindlichkeit im Lichter- und Tiefenbereich bringen.

Den Ugra/Fogra-Medienkeil CMYK gibt es in verschiedenen Layouts. Je nach Ausgabeformat können Sie zwischen ein- oder zweizeiliger Anordnung sowie unterschiedlichen Größen der Messfelder wählen.

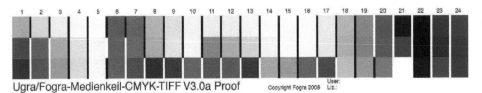

Ugra/Fogra-Medienkeil CMYK 3.0

Messfelder

Obere Reihe:	1 – 3, 6 – 8, 11 – 13 Primärfarben CMY (100%, 70%, 40%)
	4, 5, 9, 10, 14, 15 Primärfarben CMY (20%, 10%)
	16 – 21 CMY (Graubalance)
	22 Buntfarbenüberdruck auf Schwarz
	23, 24 Felder im Tiefenbereich mit L ≤ 35
Mittlere Reihe:	1 – 3, 6 – 8, 11 – 13 Sekundärfarben RGB (200%, 140%, 80%)
	4, 5, 9, 10, 14, 15 Sekundärfarben CMY (20%, 10%)
	16 – 21 CMY (Graubalance)
	22 Buntfarbenüberdruck auf Schwarz
	23, 24 Felder im Tiefenbereich mit L ≤ 35
Untere Reihe:	1– 5 CMY (Graubalance) B
	6 – 20 kritische Mischfarben A
	21 Papierweiß
	22 Buntfarbenüberdruck auf Schwarz C
	23, 24 Felder im Tiefenbereich mit L ≤ 35 D

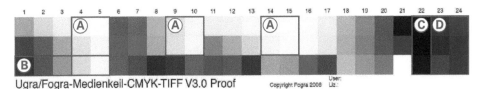

Ugra/Fogra-Medienkeil CMYK 3.0

Neue Messfelder im Vergleich zum Ugra/Fogra-Medienkeil CMYK 2.0

3.10.6 Visuelle Testformen

Als Beispiel für eine Vielzahl von visuellen Testformen sei hier der „Separationstester" genannt, den Sie zusammen mit einer Reihe weiterer Testbilder bei www.colormanagement.org herunterladen können.

Separationstester

Die Datei wurde in LAB angelegt und enthält 13 Schnitte durch den LAB-Farbraum. Separieren Sie die Datei mit Ihrem Farbprofil. Durch Anwahl der einzelnen Farbkanäle in Photoshop können Sie den Schwarzaufbau und das Farbauszugsverhalten bewerten.

Separationstester

Separiert mit dem Profil FOGRA 51 pso-coated_v3_.icc

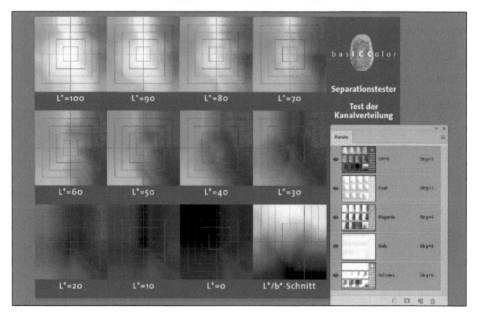

3.10.7 Altona Test Suite

Die Altona Test Suite besteht aus mehreren PDF-Dateien zur Überprüfung der digitalen Datenausgabe. Es sollen dabei vor allem die Einhaltung der PDF/X-Konformität und der Vorgaben des Color Management sichergestellt werden.

Die Entwicklung der Altona Test Suite erfolgte durch bvdm, ECI, Fogra und Ugra. Die Online-Version der Altona Test Suite ist Freeware. Sie können sie unter www.eci.org aus dem Internet herunterladen. Dort finden Sie auch weitere Informationen zu Color Management und eine ausführliche Beschreibung der Altona Test Suite.

Altona-Anwendungspaket
Das Altona-Test-Suite-Anwendungspaket ist ein Gemeinschaftsprojekt von Bundesverband Druck und Medien (bvdm) Berlin, European Color Initiative (ECI) Berlin, Forschungsgesellschaft Druck (Fogra) München und der Ugra St. Gallen. Es enthält außer einer umfangreichen Dokumentation, den Test-Suite-Dateien mit Charakterisierungstabellen auch zahlreiche Referenzdrucke und Färbungsstandards zum visuellen Vergleich von Proofs und Drucken.

Altona-Testform

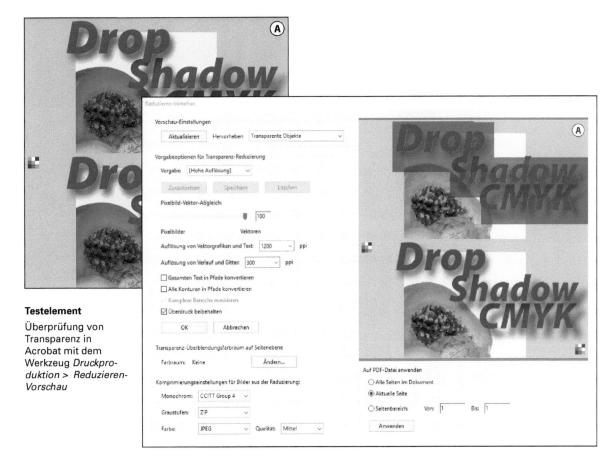

Testelement
Überprüfung von Transparenz in Acrobat mit dem Werkzeug *Druckproduktion > Reduzieren-Vorschau*

Altona Test Suite

Übersicht der Test-
formen

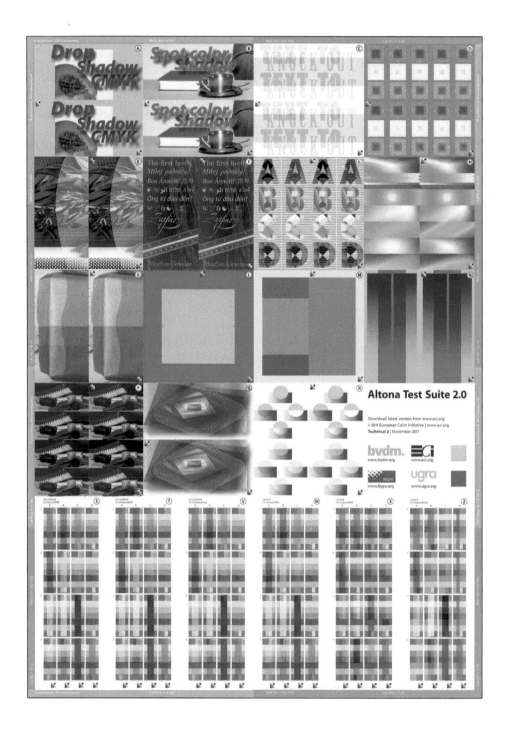

3.10.8 ECI/bvdm-Graubalance-Kontrolle

Die Graubalance und ihre Überprüfung mittels Graubalancefeldern ist in der Druckindustrie schon seit vielen Jahrzehnten als visuelles Kontrollmittel weit verbreitet. Ihre Anwendung beruht darauf, dass das menschliche Auge für Farbschwankungen im neutralen Grau besonders empfindlich ist. Sie sehen einen leichten Rotstich im Grau, schon bevor Sie die Farbschwankungen im Rotton bemerken.

	Buntgrau 70	Echtgrau 70	Buntgrau 50	Echtgrau 50	Buntgrau 30	Echtgrau 30
L*	46,75	46,75	62,72	62,72	76,38	76,38
a*	0,02	0,02	0,31	0,31	0,70	0,70
b*	–3,25	–3,25	–4,44	–4,44	–5,30	–5,30
C	64	0	43	0	25	0
M	53	0	33	0	18	0
Y	52	0	32	0	17	0
K	0	70	0	50	0	30

ECI/bvdm Gray Control Strip (S) · FOGRA 51
für den Druck auf premium gestrichene Papiere

Neu an dem gemeinsam von der ECI und dem bvdm herausgegebenen Gray Control Strip ist die Definition der Buntgraufelder über die Werte L*, a* und b*. Das Buntgrau aus CMY muss dieselben L*a*b*-Werte haben wie ein gleich helles Vergleichsfeld, das nur mit Schwarz gedruckt wird. Die L*a*b*-Werte stammen jeweils aus der Charakterisierungsdatei. Das Buntgrau ist komplett bunt, d.h. ohne Schwarz aufgebaut. Es wurde durch eine absolut farbmetrische Konvertierung des Schwarzwertes erzeugt.

Natürlich ist die Graubalance von den Druckbedingungen abhängig. Es stehen deshalb analog zu den Standarddruckprofilen auch verschiedene Gray Control Strips zu Verfügung. Das ICC-Profil und der entsprechende Gray Control Strip beruhen auf denselben Charakterisierungsdaten der Fogra.

Den Gray Control Strip gibt es in vier Layoutversionen:
- *Grundversion* S
 Der Control Strip enthält nur die sechs 6 mm x 6 mm großen Kontrollfelder.
- *Layout* Mi1
 Zu den Graubalancefeldern sind in diesem Control Strip noch Volltonfelder zur Kontrolle der Farbannahme (Trapping) und Stufenkeile zur Ermittlung der Druckkennlinien der einzelnen Druckfarben angegeben.
- *Layout* L
 Er enthält die gleichen Kontrollelemente wie die Version M. Die Stufenkeile sind aber stärker abgestuft, um eine differenziertere Erstellung der Druckkennlinie zu ermöglichen.
- *Layout tvi 10*
 Er dient der Überprüfung von Auflagendrucken nach ISO 12647. Hierfür enthält der Keil Vollton- und Übereinanderdruck- sowie Rasterfelder in 10%-Abstufung. Der ECI/bvdm tvi 10 hat keine Graubalancefelder und ist folglich für alle Druckbedingungen geeignet. Die Farbfolge der Farbfelder im Kontrollkeil „ECI/bvdm tvi 10" ist für die schnelle scannende Messung optimiert.

Der Gray Control Strip ist Freeware. Sie können ihn von den beiden Internetseiten www.eci.org und www.bvdm. org herunterladen und frei auf Ihren Drucken als Kontrollelement platzieren.

3.11 CM in Bridge

Adobe Bridge ist Teil der Adobe Creative Cloud. Bridge dient als Steuerzentrale und Bindeglied der verschiedenen Programme wie Photoshop, Illustrator und InDesign. Sie können in Bridge die Farbverwaltung für alle CC-Programme festlegen.

Farbeinstellungen definieren und abspeichern
Die Definition der Farbeinstellungen können Sie nicht direkt in Bridge vornehmen, sondern in Photoshop. Dort wählen Sie im Dialogfenster *Farbeinstellungen* unter Menü *Bearbeiten > Farbeinstellungen...* die entsprechenden Optionen. Diese Einstellungen

speichern Sie dann im Ordner „Settings" der Systemkomponente von Adobe ab.

Farbeinstellungen synchronisieren
Durch *Anwenden* A im Dialogfeld *Farbeinstellungen* synchronisieren Sie die Farbeinstellungen aller Adobe-Programme auf Ihrem Rechner. Damit ist ein konsistenter Farbworkflow beim Datenaustausch zwischen den einzelnen Programmen gewährleistet.

Im Dialogfeld der jeweiligen Programm-Farbeinstellungen wird angezeigt, ob die Farbeinstellungen synchronisiert sind.

BIME
Bibliothek der Mediengestaltung

Einheitliche Farbeinstellung für
- InDesign
- Photoshop
- Illustrator
- Acrobat

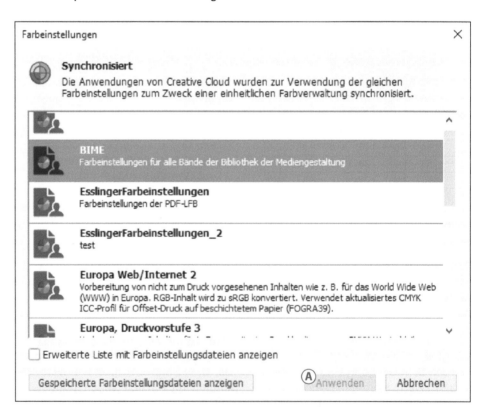

84

3.12 CM in Photoshop

3.12.1 Farbeinstellungen

Bevor Sie mit der Bildverarbeitung in Photoshop beginnen, müssen Sie die Farbeinstellungen überprüfen bzw. neu festlegen. Die Farbeinstellungen stehen unter Menü *Bearbeiten > Farbeinstellungen...*

Einstellungen

Sie haben die Möglichkeit, eine der von Photoshop angebotenen Grundeinstellungen zu wählen **A**. Durch die Synchronisation erhalten Sie in allen Programmen der Adobe CC eine einheitliche Einstellung des Farbmanagements.

Arbeitsfarbräume

Jedes Bild, das Sie in Photoshop anlegen oder bearbeiten, hat einen bestimmten Farbmodus. Mit der Auswahl des Arbeitsfarbraums definieren Sie den Farbraum innerhalb des Farbmodus, z. B. sRGB oder eciRGB.

Wenn Sie unter Menü *Bild > Modus* einen Moduswandel vornehmen, dann wird der derzeitige Arbeitsfarbraum Ihres Bildes in den von Ihnen eingestellten Arbeitsfarbraum konvertiert.

- Als RGB-Arbeitsfarbraum wählen Sie einen möglichst großen, farbmetrisch definierten Farbraum wie z. B. Adobe RGB oder den eciRGB-Farbraum. Sie können das eciRGB-Farbprofil kostenlos unter www.eci.org herunterladen und auf Ihrem Rechner installieren.
- Für den CMYK-Arbeitsraum wählen Sie das jeweilige Fortdruckprofil oder, falls der Druckprozess noch nicht feststeht, das ICC-Profil pso-coated_v3_. icc. Dieses Profil können Sie ebenfalls unter www.eci.org herunterladen.

Farbmanagement-Richtlinien

Mit den Farbmanagement-Richtlinien **B** bestimmen Sie, wie das Programm bei fehlerhaften, fehlenden oder von Ihrer Arbeitsfarbraumeinstellung abweichenden Profilen reagieren soll.

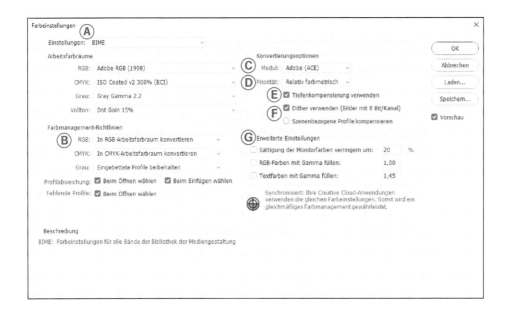

Konvertierungsoptionen

Im Bereich Konvertierungsoptionen legen Sie fest, nach welchen Regeln eine Farbmoduswandlung unter Menü *Bild > Modus* durchgeführt wird.

- *Modul* **C**
 Hier legen Sie das Color Matching Modul (CMM) fest, mit dem das Gamut-Mapping durchgeführt wird. Sie sollten immer dasselbe CMM nehmen, da die Konvertierung vom jeweiligen Algorithmus des CMM abhängt.
- *Priorität* **D**
 Die Priorität bestimmt das Rendering Intent der Konvertierung. Für Halbtonbilder wählen Sie „Perzeptiv" zum Gamut-Mapping innerhalb des RGB-Modus und zur Moduswandlung von RGB nach CMYK. Die Einstellung *Farbmetrisch* dient der Konvertierung zum Proofen. Mit *Absolut farbmetrisch* simulieren Sie das Auflagenpapier, mit *Relativ farbmetrisch* bleibt dieses unberücksichtigt. *Sättigung* ist die Option für flächige Grafiken.

- *Tiefenkompensierung* **E**
 Durch das Setzen dieser Option können Sie den Dichteumfang des Quellfarbraums an den des Zielfarbraums anpassen. Dadurch bleiben alle Tonwertabstufungen auch in den Tiefen, den dunklen Bildbereichen, erhalten.
- *Dither anwenden* **F**
 Die Ditheringfunktion bewirkt bei der Farbraumkonvertierung eine bessere Darstellung in den glatten Tönen und Verläufen des Bildes. Sie verhindern durch die Auswahl dieser Option weitgehend die Stufen- bzw. Streifenbildung.

Erweiterte Einstellungen G

Mit den erweiterten Einstellungen können Sie die Darstellung eines großen Arbeitsfarbraums durch einen kleineren Monitorfarbraum anpassen. Diese Einstellungen sind nicht empfehlenswert, da die veränderte Bildschirmdarstellung der Farben eines Bildes keine Rückschlüsse auf die Druckausgabe mehr zulässt.

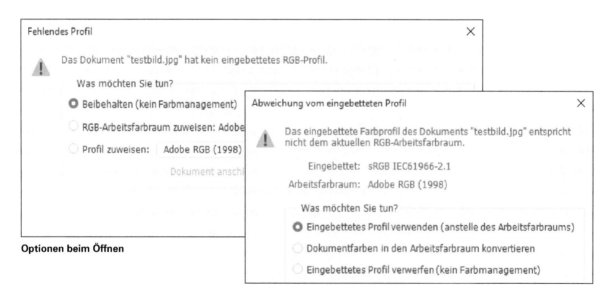

Optionen beim Öffnen

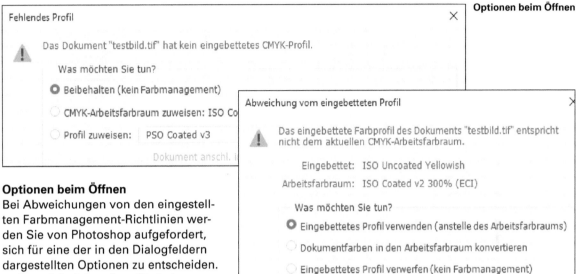

Fehlendes Profil ✕

⚠ Das Dokument "testbild.tif" hat kein eingebettetes CMYK-Profil.

Was möchten Sie tun?

◉ Beibehalten (kein Farbmanagement)

○ CMYK-Arbeitsfarbraum zuweisen: ISO Co

○ Profil zuweisen: PSO Coated v3

Dokument anschl. i

Abweichung vom eingebetteten Profil ✕

⚠ Das eingebettete Farbprofil des Dokuments "testbild.tif" entspricht nicht dem aktuellen CMYK-Arbeitsfarbraum.

Eingebettet: ISO Uncoated Yellowish

Arbeitsfarbraum: ISO Coated v2 300% (ECI)

Was möchten Sie tun?

◉ Eingebettetes Profil verwenden (anstelle des Arbeitsfarbraums)

○ Dokumentfarben in den Arbeitsfarbraum konvertieren

○ Eingebettetes Profil verwerfen (kein Farbmanagement)

Optionen beim Öffnen

Bei Abweichungen von den eingestellten Farbmanagement-Richtlinien werden Sie von Photoshop aufgefordert, sich für eine der in den Dialogfeldern dargestellten Optionen zu entscheiden.

Grundsätzlich sollten Sie beim Öffnen nie konvertieren. Schauen Sie sich das Bild erst an, Sie haben bei der Bildverarbeitung immer noch alle Optionen.

3.12.2 Gamut-Mapping

Menü Bild > Modus
Die einfachste Methode, einem bereits geöffneten Bild ein neues Profil zuzuweisen, ist der Moduswandel unter Menü *Bild > Modus*. Photoshop verwendet dazu die von Ihnen im Dialogfeld *Farbeinstellungen* gewählten Konvertierungsoptionen.

Menü Bearbeiten > Profil zuweisen...
Mit dieser Option weisen Sie Ihrer Bilddatei ein neues Farbprofil zu. Abhängig davon, wie stark sich Quell- und Zielfarbraum unterscheiden, verändert sich die Bildschirmdarstellung der Bilddatei. Da Photoshop das neue Profil aber nur als Tag an die Bilddatei anhängt, werden die Farben nicht in den Profilfarbraum konvertiert.

Profil zuweisen ✕

Profil zuweisen:

○ Farbmanagement auf dieses Dokument nicht anwenden

○ CMYK-Arbeitsfarbraum: ISO Coated v2 300% (ECI)

◉ Profil: PSO Coated v3

(OK)
(Abbrechen)
☑ Vorschau

Menü Bearbeiten > In Profil umwandeln...
Diese Option hat die gleiche Auswirkung auf die Bilddatei wie die Moduswandlung unter Menü *Bild > Modus*. Der Vorteil liegt aber darin, dass Sie bei einem einzelnen Bild eine Farbraum-

konvertierung durchführen können, ohne die allgemeinen Farbeinstellungen verändern zu müssen. Außerdem bietet Ihnen die Vorschau die Möglichkeit, unter Sichtkontrolle die optimale Konvertierungseinstellung auszuwählen.

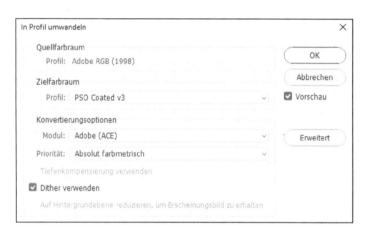

- *Kein Farbmanagement*
 Die Farbwerte werden vor der Ausgabe weder von Photoshop noch vom Drucker verändert.

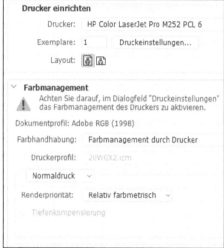

3.12.3 Digital Proofen und Drucken

Natürlich müssen Sie die Farbeinstellungen nicht nur beim Öffnen und Bearbeiten der Bilddatei beachten, sondern auch bei der Ausgabe, d. h. dem Proofen oder Drucken. Sie finden die Farbmanagementeinstellungen unter Menü *Datei > Drucken > Farbmanagement*. Photoshop bietet folgende Optionen:

- *Farbverwaltung durch Drucker*
 Der Drucker bzw. die Druckersoftware konvertiert die Farbwerte der Datei in die Farbwerte des Druckerfarbraums.
- *Farbverwaltung durch Photoshop*
 Die Farbeinstellungen des Druckers werden von Photoshop überschrieben. Natürlich setzt diese Einstellung voraus, dass Sie die korrekten Profile ausgewählt und eingestellt haben.

3.12.4 Speichern der Bilddatei

Für den Farbmanagement-Workflow müssen Sie das Farbprofil Ihrer Bilddatei immer mit abspeichern.

Im Speichern-Dialog von Photoshop sind alle Dateiformate, die Profile unterstützen, zur Auswahl aufgelistet.

Die Option *Farbprofil einbetten* bewirkt, dass das Farbprofil als Tag an die Bilddatei angehängt und dadurch mit abgespeichert wird.

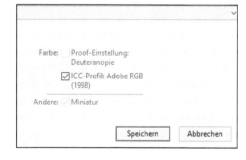

3.13 CM in Illustrator

3.13.1 Farbeinstellungen

Natürlich müssen Sie auch in Illustrator für einen konsistenten Color-Management-Workflow die entsprechenden Farbeinstellungen vornehmen. Wählen Sie dazu unter Menü *Bearbeiten > Farbeinstellungen...* Ihre Profile aus. Grundsätzlich gelten dabei die gleichen Regeln wie in Photoshop.

Optionen beim Öffnen
Bei Abweichungen von den eingestellten Farbmanagement-Richtlinien werden Sie von Illustrator aufgefordert, sich für eine der in den Dialogfeldern dargestellten Optionen zu entscheiden.
Grundsätzlich sollten Sie beim Öffnen nie konvertieren. Schauen Sie sich die Grafik erst an, Sie haben bei der Bearbeitung immer noch alle Optionen.

Profil zuweisen
Diese Option kennen Sie ebenfalls schon aus Photoshop. Sie finden sie unter Menü *Bearbeiten > Profil zuweisen...*

Farbmodus wechseln
Unter Menü *Datei > Dokumentfarbmodus* können Sie zwischen dem RGB-Modus und dem CMYK-Modus wechseln. Die Auswahl des Arbeitsfarbraums erfolgt nach Ihren Einstellungen im Dialogfeld Farbeinstellungen.

Digital Proofen und Drucken
Die Farbeinstellungen im Dialogfeld *Drucken* unter der Option *Farbmanagement* ermöglichen es, einen farbrichtigen Ausdruck bzw. Proof Ihrer Grafik zu erstellen.
- *Illustrator bestimmt die Farben* mit eigenen Einstellungen,
- *Drucker bestimmt Farben* mit vordefinierten Einstellungen.

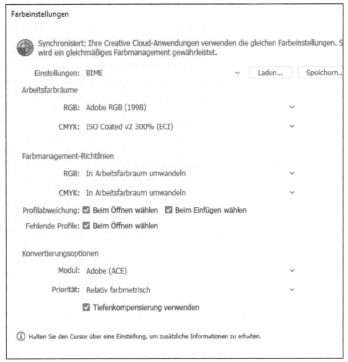

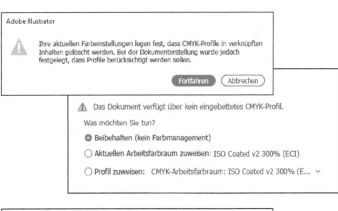

3.14 CM in InDesign

3.14.1 Farbeinstellungen

Als letzten Schritt im Workflow führen Sie Bild und Grafik im Layoutprogramm zusammen. Die Farbprofile Ihrer Dateien werden natürlich auch hier in InDesign weiter mitgeführt. Deshalb

müssen Sie auch in InDesign die Farbeinstellungen **A** kontrollieren und ggf. modifizieren. Gehen Sie dazu ins Menü *Bearbeiten > Farbeinstellungen...* Für die Einstellungen gelten die gleichen Regeln wie in Photoshop.

Optionen beim Öffnen
Bei Abweichungen von den eingestellten Farbmanagement-Richtlinien **B** werden Sie von InDesign aufgefordert, sich für eine der in den Dialogfeldern dargestellten Optionen zu entscheiden.
 Grundsätzlich sollten Sie beim Öffnen nie konvertieren. Schauen Sie sich die Datei erst an, Sie haben bei der Bearbeitung immer noch alle Optionen.

Profil zuweisen C
Diese Option kennen Sie ebenfalls schon aus Photoshop. Sie finden sie unter Menü *Bearbeiten > Profil zuweisen...*

Profil umwandeln D
Im Gegensatz zur Profilzuweisung werden mit Menü *Bearbeiten > In Profil umwandeln...* die Farbwerte tatsächlich neu berechnet. Sie können damit partiell die generellen Vorgaben in den Farbeinstellungen überschreiben.

Digital Proofen und Drucken E
Die Farbeinstellungen im Dialogfeld *Drucken* unter der Option *Farbmanagement* ermöglichen es, einen farbrichtigen Ausdruck bzw. Proof Ihres Dokuments zu erstellen.
 Sie haben die Wahl zwischen den beiden Optionen
- *InDesign bestimmt die Farben* mit eigenen Einstellungen,
- *Drucker bestimmt Farben* mit vordefinierten Einstellungen.

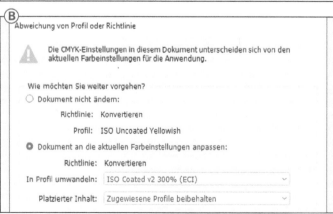

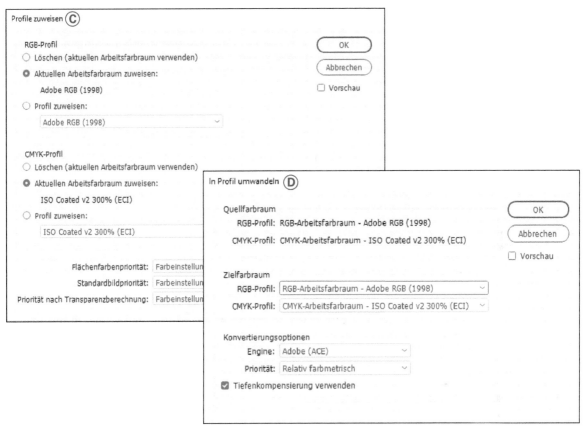

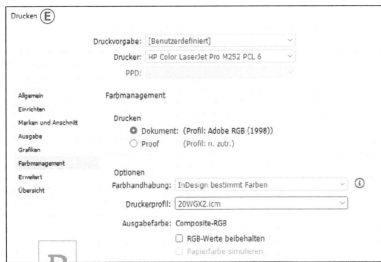

3.15 CM in Distiller und Acrobat

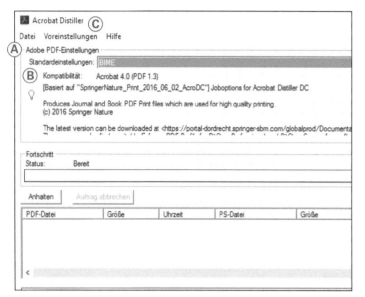

3.15.1 Farbeinstellungen in Distiller

Die Adobe PDF-Einstellungen **A** definieren alle Einstellungsparameter bei der PDF-Erstellung. Die Auswahl der Einstellung treffen Sie bei Standardeinstellungen **B**. Die Verwaltung der PDF-Einstellungen erfolgt unter Menü *Voreinstellungen* **C**.

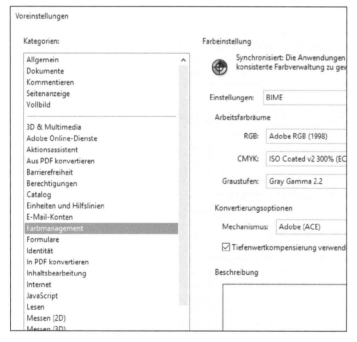

3.15.2 Farbeinstellungen in Acrobat

In Acrobat können Sie in der PDF-Datei die Farbeinstellungen noch verändern. Sie können in Acrobat den Farbdateien Profile zuweisen oder festlegen, dass die mitgeführten Profile beibehalten werden. Die Einstellungen machen Sie unter Menü *Acrobat > Voreinstellungen... > Farbmanagement*.

Mit der Option *OutputIntent überschreibt Arbeitsfarbräume* werden die eingebetteten Farbprofile durch die hier eingestellten Profile ersetzt. Eine Option, die wohl überlegt sein will. Wählen Sie diese Option nur dann, wenn die bisherigen Arbeitsfarbräume bzw. Farbprofile für die neue Ausgabe nicht mehr gültig sind und durch die neuen Profile ersetzt werden müssen. So z. B., wenn das Dokument jetzt in einem anderen Druckverfahren gedruckt werden soll.

3.16 Aufgaben

**1 Color-Management-System be-
schreiben**

Welche Aufgaben hat ein Color-Ma-
nagement-System?

2 Farbmetrik erläutern

Mit welchen Inhalten befasst sich die
Farbmetrik.

3 ICC kennen

Welche Organisation verbirgt sich hin-
ter der Abkürzung ICC?

4 Digitalkamera profilieren

Welche Rolle spielt die Beleuchtung bei
der Profilierung einer Digitalkamera?

5 Monitor profilieren

Welche Punkte müssen Sie beachten,
bevor Sie mit der Monitorprofilierung
beginnen können?

6 Druck profilieren

Nennen Sie die Schritte der Ausgabe-
profilierung.

**7 Separationseinstellungen im ICC-
Profil kennen**

Warum sind die Separationseinstel-
lungen Teil der Ausgabe-Profilerstel-
lung?

8 ECI kennen

Was bedeutet die Abkürzung ECI?

9 ECI-Standardprofile erläutern

Für welche Papiere und Druckverfahren
sind die ECI-Standardprofile zu verwen-
den?
a. FOGRA 51
b. FOGRA 52

a.

b.

10 Arbeitsfarbraum erklären

Was ist ein Arbeitsfarbraum?

11 PCS erläutern

Was ist ein PCS?

12 Rendering Intent kennen

Was ist ein Rendering Intent?

13 Nennen Sie die drei Rendering-Intent-Optionen.

1.

2.

3.

14 Rendering Intent wählen

Welches Rendering Intent wählen Sie zum Gamut-Mapping beim
a. Öffnen einer RGB-Datei aus der Digitalfotografie,
b. Proofen mit Simulation des Papierweiß Ihres Auflagenpapiers?

a.

b.

15 Bildschirmhintergrundbild auswählen

Welchem Zweck dient ein neutralgraues Bildschirmhintergrundbild?

16 Mittleres Grau mit Farbwerten festlegen

Welche RGB-Werte ergeben ein neutrales mittleres Grau?

17 Ugra/Fogra-Medienkeil erklären

a. Wozu dient der Ugra/Fogra-Medienkeil?
b. Welche ISO-Normen sind die Grundlage der Verwendung des Medienkeils?

a.

b.

18 Ugra/Fogra-Medienkeil erklären

Welche Farben enthält der Medienkeil
in den Farbfeldern 1-3, 6-8 und 11-13
der
a. oberen Reihe,
b. mittleren Reihe?

a.

b.

19 Graubalance überprüfen

Wie wird die Graubalance im Medien-
keil überprüft?

20 Farbmanagement-Richtlinien erklären

Was regeln die Farbmanagement-
Richtlinien?

21 Altona Test Suite kennen

Nennen Sie zwei technische Parameter,
die mit Hilfe der Testformen überprüft
werden können.

1.

2.

22 Farbeinstellungen

a. In welcher Adobe-Software können
die Farbeinstellungen der Adobe CC
synchronisiert werden?
b. Beschreiben Sie die Vorgehensweise.

a.

b.

23 Farbeinstellungen

Warum ist es sinnvoll, die Farbeinstel-
lungen der Adobe CC zu synchronisie-
ren?

24 Profile installieren

Warum ist die Installation von Farbpro-
filen auf PC und Mac verschieden?

4.1 Lösungen

4.1.1 Farben sehen

1 Farbensehen erläutern

Die Netzhaut des Auges enthält die Fotorezeptoren (Stäbchen und Zapfen). Die Rezeptoren wandeln als Messfühler den Lichtreiz in Erregung um. Nur die Zapfen sind farbtüchtig. Es gibt drei verschiedene Zapfentypen, die je für Rot, Grün oder Blau empfindlich sind. Jede Farbe wird durch ein für sie typisches Erregungsverhältnis dieser drei Rezeptorentypen bestimmt.

2 Farbvalenz definieren

Die Farbvalenz ist die Bewertung eines Farbreizes durch die drei Empfindlichkeitsfunktionen des Auges.

3 Farbkontraste kennen

1. Komplementärkontrast
2. Simultankontrast
3. Warm-kalt-Kontrast
4. Hell-Dunkel-Kontrast

4 Farbkontraste in ihrer Wirkung beschreiben

Die Wirkung von Farben im Umfeld heißt Simultankontrast.

5 Kenngrößen einer Welle definieren

a. Wellenlänge λ (m): Abstand zweier Perioden, Kenngröße für die Farbigkeit des Lichts
b. Amplitude: Auslenkung der Welle, Kenngröße für die Helligkeit des Lichts

6 Strahlerarten erläutern

a. Bei Primärstrahlern trifft die von der Lichtquelle emittierte Strahlung direkt auf den Strahlungsempfänger.
b. Bei Sekundärstrahlern trifft die von der Lichtquelle emittierte Strahlung zunächst auf eine Oberfläche, wird von dieser remittiert und trifft dann auf den Strahlungsempfänger.

7 Visuelle Wahrnehmung erläutern

1. Farbreiz
2. Stimmung und Gefühle
3. Wahrnehmung anderer Sinnesorgane
4. Erfahrung

4.1.2 Farbsysteme

1 Grundfarben digitaler Medien kennen

RGB – Rot, Grün und Blau

2 Grundfarben des Drucks kennen

CMYK – Cyan, Magenta, Gelb und Schwarz

© Springer-Verlag GmbH Deutschland 2018
P. Bühler, P. Schlaich, D. Sinner, *Digitale Farbe*, Bibliothek der Mediengestaltung,
https://doi.org/10.1007/978-3-662-54607-9

3 Farbkreis kennen

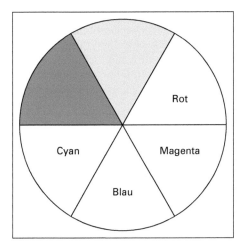

4 Farbsysteme kennen

a. Rot, Grün und Blau (RGB)
b. Das menschliche Farbensehen erfolgt durch die Addition der drei Teilreize (Farbvalenzen) der drei Zapfenarten (rot-, grün- und blau-empfindlich). Man nennt deshalb die additive Farbmischung auch physiologische Farbmischung.

5 Farbsysteme kennen

a. Cyan, Magenta und Yellow (Gelb), CMY
b. Die subtraktive Farbmischung ist unabhängig vom menschlichen Farbensehen. Deshalb nennt man die subtraktive Farbmischung auch physikalische Farbmischung.

6 Farbsysteme kennen

Prozessunabhängige Farbsysteme definieren Farbwerte absolut. Sie sind von Soft- und Hardwareeinstellungen und Produktionsprozessen unabhängig.

7 Farbortbestimmung im Normvalenzsystem kennen

- Farbton T
 Lage des Farborts auf der Außenlinie
- Sättigung S
 Entfernung des Farborts von der Außenlinie
- Helligkeit Y
 Ebene im Farbkörper, auf der der Farbort liegt

8 Farbortbestimmung im CIELAB-System kennen

- Helligkeit L* (Luminanz)
 Ebene des Farborts im Farbkörper
- Sättigung C* (Chroma)
 Entfernung des Farborts vom Unbuntpunkt
- Farbton H* (Hue)
 Richtung, in der der Farbort vom Unbuntpunkt aus liegt

9 Arbeitsfarbraum erklären

Der Arbeitsfarbraum ist der Farbraum, in dem die Bearbeitung von Dokumenten vorgenommen wird.

10 Farbabstand kennen

Der Farbabstand ΔE^* ist die Strecke zwischen zwei Farborten im CIELAB-Farbraum.

11 Metamerie erklären

Unbedingt-gleiche Farben sind Farben mit identischen Spektralfunktionen. Unbedingt-gleiche Farben sind unabhängig von der Beleuchtung visuell nie unterscheidbar.

12 Farbwiedergabe in einer Farbtafel

1. Papier
2. Druckverfahren
3. Beleuchtung

13 Metamerie erklären

Bedingt-gleiche Farben sind Farben, die unter einer bestimmten Beleuchtung visuell nicht unterscheidbar sind, aber unterschiedliche spektrale Transmissions- bzw. Remissionskurven haben.

4.1.3 Color Management

1 Color-Management-System beschreiben

In einem CMS werden die einzelnen Systemkomponenten des Farbworkflows von der Bilddatenerfassung über die Farbverarbeitung bis hin zur Ausgabe in einem einheitlichen Standard erfasst, kontrolliert und abgestimmt.

2 Farbmetrik erläutern

Die Farbmetrik entwickelt Systeme zur quantitativen Erfassung und Kennzeichnung der Farbeindrücke (Farbvalenzen). Das menschliche Farbensehen wird dadurch messtechnisch erfassbar.

3 ICC kennen

Das ICC, International Color Consortium, ist ein Zusammenschluss führender Soft- und Hardwarehersteller unter der Federführung der Fogra, das die allgemeinen Regelungen für das Color Management festgelegt hat.

4 Digitalkamera profilieren

Die Beleuchtung beeinflusst die Farbigkeit des Motivs und damit der Aufnahme. Verschiedene Beleuchtungssituationen mit unterschiedlicher Lichtart bedingen deshalb einen speziellen Weißabgleich und eigene Profilierung.

5 Monitor profilieren

- Der Monitor soll wenigstens eine halbe Stunde in Betrieb sein.
- Kontrast und Helligkeit müssen auf die Basiswerte eingestellt sein.
- Die Monitorwerte dürfen nach der Messung und anschließender Profilierung nicht mehr verändert werden.
- Bildschirmschoner und Energiesparmodus müssen deaktiviert sein.

6 Druck profilieren

1. Andrucken der Testform
2. Farbmetrisches Ausmessen des Testdrucks
3. Generieren des ICC-Profils
4. Speichern des Profils

7 Separationseinstellungen im ICC-Profil kennen

Die Separation erfolgt im CM-Workflow durch die Farbraumtransformation vom RGB-Farbraum in den CMYK-Ausgabefarbraum. Die Separation muss deshalb im Profil festgelegt sein.

8 ECI kennen

ECI, European Color Initiative, neben dem ICC die Organisation zur Definition der CM-Richtlinien.

9 ECI-Standardprofile erläutern

a. FOGRA 51 (pso-coated_v3_.icc):
 Offset auf premium gestrichenem
 Papier
b. FOGRA 52 (pso-uncoated_v3.icc):
 Offset auf holzfrei ungestrichen wei-
 ßem Papier

10 Arbeitsfarbraum erklären

Der Arbeitsfarbraum ist der Farbraum,
in dem die Bearbeitung von Bildern,
z. B. Ton- und Farbwertretuschen, vor-
genommen wird.

11 PCS erläutern

PCS, Profile Connection Space, ist der
prozessunabhängige Farbraum, in dem
das Gamut-Mapping stattfindet.

12 Rendering Intent kennen

Das Rendering Intent ist der Umrech-
nungsalgorithmus der Farbraumtrans-
formation.

13 Nennen Sie die drei Rendering-Intent-Optionen.

1. perzeptiv bzw. perceptual
2. Sättigung bzw. saturation
3. relativ farbmetrisch bzw. relative
 colorimetric
4. absolut farbmetrisch bzw. absolute
 colorimetric

14 Rendering Intent wählen

a. perzeptiv oder relativ farbmetrisch
b. absolut farbmetrisch

15 Bildschirmhintergrundbild auswählen

Ein neutralgraues Bildschirmhinter-
grundbild dient der visuellen Kontrolle
der Farbbalance des Monitors.

16 Mittleres Grau mit Farbwerten festlegen

$R = G = B = 127$

17 Ugra/Fogra-Medienkeil erklären

a. Der Ugra/Fogra-Medienkeil ist ein di-
 gitales Kontrollmittel, das zusammen
 mit der Seite ausgegeben wird. Er
 dient zur Kontrolle der Farbverbind-
 lichkeit von Proof und Druck.
b. ISO 12642 und ISO 12647

18 Ugra/Fogra-Medienkeil erklären

a. Primärfarben in den Abstufungen
 100%, 70% und 40%
b. Sekundärfarben in den Abstufungen
 200%, 140% und 80%

19 Graubalance überprüfen

Die Graubalance wird mit den Ver-
gleichsfeldern K und CMY auf der rech-
ten Seite im Medienkeil überprüft.

20 Farbmanagement-Richtlinien erklären

Die Farbmanagement-Richtlinien
bestimmen, wie das Programm, z. B.
Photoshop, bei fehlerhaften, fehlenden
oder von Ihrer Arbeitsfarbraumeinstel-
lung abweichenden Profilen reagiert.

21 Altona Test Suite kennen

1. PDFX-Konformität
2. Farbrichtigkeit

22 Farbeinstellungen

a. Adobe Bridge
b.
1. Farbeinstellungen in Bridge öffnen
2. Profil auswählen
3. Button *Anwenden* zum Synchronisieren anklicken

23 Farbeinstellungen

Durch das Synchronisieren haben alle Programme der Adobe CC dieselben Farbeinstellungen. Damit gibt es keine Farbabweichungen beim Dateiaustausch zwischen den Programmen.

24 Profile installieren

Die Installation der Farbprofile auf dem Computer unterscheidet sich bedingt durch das Betriebssystem bei macOS und Windows.

4.2 Links und Literatur

Links

Adobe
www.adobe.com/de

Adobe TV
tv.adobe.com/de

European Color Initiative (ECI)
www.eci.org/de

Fogra Forschungsgesellschaft Druck e.V.
www.fogra.org

Farbmessgeräte
www.xrite.com/de
www.techkon.com

Farbmanagementsoftware
www.basiccolor.de
www.efi.com/de-de
www.gmgcolor.com/de

Literatur

Joachim Böhringer et al.
Kompendium der Mediengestaltung
Springer Vieweg Verlag 2014
ISBN 978-3642548147

Joachim Böhringer et al.
Printmedien gestalten und digital produzieren:
mit Adobe CS oder OpenSource-Programmen
Europa-Lehrmittel Verlag 2013
ISBN 978-3808538081

Kaj Johansson, Peter Lundberg
Printproduktion Well done!
Schmidt Verlag 2008
ISBN 978-3874397315

Monika Gause
Adobe Illustrator CC
Rheinwerk Design Verlag 2017
ISBN 978-3836245050

Hans Peter Schneeberger, Robert Feix
Adobe InDesign CC
Rheinwerk Design Verlag 2016
ISBN 978-3836240079

Markus Wäger
Adobe Photoshop CC
Rheinwerk Design Verlag 2016
ISBN 978-3836242677

Thomas Hoffmann-Walbeck et al.
Standards in der Medienproduktion
Springer Vieweg Verlag, 2013
ISBN 978-3642150425

Sibylle Mühlke
Adobe Photoshop CC
Rheinwerk Design Verlag 2016
ISBN 978-3836240062

4.3 Abbildungen

S2, 1: Autoren
S3, 1a, b, 2, 3, 4: Autoren
S4, 1, 2: Autoren
S5, 1a, b, 2: Autoren
S6, 1, 2a, b: Autoren
S7, 1: Autoren
S8, 1a, b, c, 2a, b: Autoren
S10, 1: Autoren
S11, 1, 2: Autoren
S12, 1a b: BVDM
S12, 2: Fogra
S13, 1: Autoren
S14, 1: Konica
S14, 1: X-Rite
S15, 1a: Techkon
S15, 1b: bvdm
S15, 2a: Autoren
S15, 2b, c: Techkon
S16, 1: Autoren
S17, 1, 2, 3: Autoren
S18, 1, 2a, b, c, 3a, b, c, 4a, b, c: Autoren
S19, 1, 2a, b: Autoren
S20, 1a, b: Autoren
S21, 1, 2: Autoren
S22, 1: Autoren
S23, 1a, b, 2a, b: Autoren
S24, 1a, b: Autoren
S25, 1: Autoren
S26, 1, 2: Autoren
S27, 1: Autoren
S28, 1: Autoren
S29, 1a, b, 2a, b: Autoren
S30, 1: Autoren
S31, 1: Autoren
S32, 1a, b: Autoren
S33, 1: Autoren
S34, 1, 2: Autoren
S35, 1: Autoren
S36, 1: Autoren
S38, 1, 2: Autoren
S39, 1: Autoren
S40, 1: Autoren
S42, 1a, b, 2: Autoren
S44, 1: Autoren
S46, 1: Autoren
S47, 1: bvdm

S48, 1: ISO 12647-2013
S49, 1, 2: Fogra
S50, 1: Autoren
S51, 1: Autoren
S52, 1: Fogra
S53, 1, 2, 3: Autoren
S54, 1, 2: Autoren
S55, 1, 2, 3: Autoren
S56, 1a, b, 2a, b: Autoren
S57, 1, 2: Autoren
S58, 1, 2: Autoren
S59, 1, 2: Autoren
S60, 1, 2: Autoren
S61, 1, 2: Autoren
S62, 1: Autoren
S63, 1, 2: Autoren
S64, 1, 2: Autoren
S65, 1, 2: Autoren
S66, 1, 2: Autoren
S68, 1, 2: Autoren
S69, 1a, b, 2a, b, 3a, b: Autoren
S70, 1, 2: Autoren
S71, 1, 2, 3: Autoren
S72, 1: Autoren
S73, 1, 2: Autoren
S74, 1, 2, 3: Autoren
S75, 1, 2, 3: Autoren
S76, 1: Eizo
S76, 2: Just
S77, 1: Just
S77, 2: Autoren
S78, 1: Epson
S79, 1, 2: Autoren
S80, 1, 2: Autoren
S81, 1: Autoren
S82, 1: bvdm
S83, 1: bvdm
S84, 1: Autoren
S85, 1: Autoren
S87, 1: Autoren

4.4 Index